CREATED
TO HEAR
GOD
JOURNAL

CREATED
TO HEAR
GOD
JOURNAL

A DAILY GUIDE TO DEVELOP
4 UNIQUE AND PROVEN WAYS TO
CONFIDENTLY DISCERN HIS VOICE

HAVILAH CUNNINGTON

NELSON
BOOKS

An Imprint of Thomas Nelson

Published in Nashville, Tennessee, by Nelson Books, an imprint of Thomas Nelson. Nelson Books and Thomas Nelson are registered trademarks of HarperCollins Christian Publishing, Inc.

The author is represented by Alive Literary Agency, www.aliveliterary.com.

Thomas Nelson titles may be purchased in bulk for educational, business, fundraising, or sales promotional use. For information, please email SpecialMarkets@ ThomasNelson.com.

Unless otherwise noted, Scripture quotations are taken from The Holy Bible, New International Version®, NIV®. Copyright © 1973, 1978, 1984, 2011 by Biblica, Inc.® Used by permission of Zondervan. All rights reserved worldwide. www.Zondervan. com. The "NIV" and "New International Version" are trademarks registered in the United States Patent and Trademark Office by Biblica, Inc.®

Scripture quotations marked AMP are taken from the Amplified® Bible (AMP). Copyright © 2015 by The Lockman Foundation. Used by permission. www.lockman.org

Scripture quotations marked ERV are taken from the HOLY BIBLE: EASY-TO-READ VERSION © 2001 by World Bible Translation Center, Inc. and used by permission.

Names and identifying characteristics of some individuals have been changed to preserve their privacy.

Library of Congress Cataloging-in-Publication Data

Names: Cunnington, Havilah, 1977- author.
Title: Created to hear God journal : a daily guide to develop 4 unique and proven ways to confidently discern his voice / Havilah Cunnington.
Description: Nashville, Tennessee : Thomas Nelson, [2024] | Summary: "Come journal the journey with pastor and Truth to Table founder Havilah Cunnington and discover how God speaks to you!"-- Provided by publisher.
Identifiers: LCCN 2024016191 | ISBN 9781400238675 (tp)
Subjects: LCSH: God (Christianity)--Omnipresence. | Presence of God. | Christian life.
Classification: LCC BT132 .C96 2024 | DDC 231.7--dc23/eng/20240523
LC record available at https://lccn.loc.gov/2024016191

Printed in the United States of America

24 25 26 27 28 LBC 5 4 3 2 1

Mom and Dad,
This book is for you. From day one you've been my biggest
champions, guiding me with unwavering love and wisdom.
You taught me to hear God's voice and experience His
tangible presence. Your influence has shaped my journey in
ways that words can hardly express. Being your daughter
has been an incredible privilege, giving me a wealth
of spiritual resources, but also the understanding that
the true power lies in giving them away. This message
is the fruit of the seeds you planted in me long ago.
All my love and gratitude,
Havilah

CONTENTS

A NOTE FROM HAVILAH

FRIEND, YOU AND I ARE ABOUT TO GO ON A LITTLE adventure together. (And by *little*, I obviously mean huge, gargantuan, potentially life-changing.) Specifically, you'll have the opportunity to discover how God has uniquely wired you to hear His voice by identifying your Prophetic Personality. If you don't identify as the adventurous type, no worries; I'm going to guide you step-by-step to discover what I anticipate will in many ways feel like strangely familiar territory.

Here's a quick peek at what we'll experience together:

- On the first leg of the journey, we'll consider how you've been uniquely made to hear God.
- After a brief breather I'll introduce you to the four Prophetic Personality types.
- Then, to get you *really* ready, you'll have the opportunity to consider and define what your unique type might be.

- To confirm or challenge what you think your Prophetic Personality might be, I'll offer a tool you can use to identify your type!
- After that you'll spend some time exploring the landscape of what that looks like for you.
- Finally, before I leave you, I'll offer essentials to keep you healthy for the rest of your life with God.

This journey to explore your Prophetic Personality is going to change your life, and I'm excited!

IN IT WITH YOU,

Havilah

I WANT TO HEAR GOD

JANICE, A TWENTY-SEVEN-YEAR-OLD MIDDLE SCHOOL teacher, always wanted to hear from God. But like a lot of people, she assumed that God only spoke to "other people."

Janice and I were having coffee one morning when she shared with me an encounter she'd recently had over dinner with her brother. She explained, "My brother was just telling me about his new job. And when he said the name of his new boss, I instantly had the thought in my head, *This guy's wife has cancer.* I didn't say anything about it—because it seemed super weird and random—but I later found out it was true."

All I could think was, *Wow! That's amazing!*

I usually don't hear God like that, but I recognized that Janice was hearing God differently than I do.

If you've ever wondered if God can or will speak to you, buckle up.

THE LIE: ONLY OTHER PEOPLE HEAR FROM GOD

It can be tempting to believe that everyone *except* us can hear God. Or that God has His favorites who can hear God clearly (like Janice!). Or that only people who've been given a special gift can hear God.

Think about someone you know personally who reports that he or she hears from God.

The person I know of who hears from God is

Now think of a public person—a leader, influencer, mover and shaker, or hero of the faith—who reports that he or she hears from God.

A public person who hears from God is

When I think of these people and the ways they hear from God, the story I tell myself about them is

"I CAN'T HEAR FROM GOD"

There are lots of reasons that people like you and me have come to believe that we can't hear from God. Are any of these familiar to you?

☐ I can't hear God because God is unhappy with me.

☐ I can't hear God because I've done something to upset God.

☐ I can't hear God because I'm not spiritual enough.

☐ I can't hear God because I'm not mature enough in my faith.

☐ I can't hear God because I'm not holy or disciplined enough to hear God.

☐ I can't hear God because I haven't been given the special gift that others have.

☐ I can't hear God because I have some kind of learning disability.

☐ I can't hear God because _____

Which of the reasons you chose is the one that's *loudest* in your head? Circle the checkbox.

WHEN WELL-MEANING PEOPLE AREN'T HELPING

A lot of people—parents, friends, pastors, other spiritual leaders—mean well when they assure us that we can hear God. But sometimes it's not really helpful. Which of these assurances have you received from others?

☐ "God will speak to you."

☐ "You'll know God's voice when you hear it."

☐ "All you need to do is ask. And then ask again. And then keep asking."

☐ "Listen hard enough and you'll hear God."

☐ "Just read your Bible. That's how God speaks to you."

☐ Or something else? Note your own experience: _____

IT CAN GET NOISY

Those of us who don't think that we're hearing from God aren't necessarily sitting in *silence*. In fact, it might get super noisy in our heads! And I want to suggest that we can hear—loudly or quietly—three different voices:

our own voice
the Enemy's voice
God's voice

I know you're familiar with these voices inside you! You've heard messages like "You're not worth loving" or "You deserved it" or "You'll never succeed" or "God isn't listening." But you know that these are not God's voice.

So how can we discern which is which?

Here's a handy guide:

- We can recognize when a thought or message is our own voice if we feel a sense of fear, anxiety, shame, or dread.

- We can recognize when a thought or message is the Enemy's voice because it comes to accuse, condemn, or blame us.
- We can recognize when a thought or message is God's voice because it's filled with hope, love, peace, and faith.

As you think about these three voices inside you, notice and record ways that you've heard each one.

The messages I've heard that are from *me* are

The messages I've heard that are from *the Enemy* are

The messages I've heard that are from *God* are

PRAY: God, I thank You that Your Holy Spirit gives me the power to hear Your voice and to notice what is *not* Your voice. In Jesus' name, amen.

When you've tried to hear God's voice in the past and become frustrated, what were some of the ways you tuned in to His voice? (Be specific.)

☐ I listened to this expert: _____

☐ I turned to this person: _____

☐ I followed this person on socials: _____

☐ I read this book: _____

☐ I bought this journal: _____

☐ I visited this church: _____

☐ I attended this conference: _____

☐ I attended this retreat: _____

☐ I dug into the Scriptures. And the ones I remember are ___

☐ I joined this prayer meeting/group/call: _____

☐ I fasted in this way, for this period of time: _____

☐ I prayed and begged God to speak up. My prayer might have sounded something like this:

WE WANT TO HEAR FROM GOD

If we're skeptical that we'll hear from God, we're likely not going to ask God about much of anything or *for* much of anything. But

as we grow in our confidence that we really can hear from God, we are able to bring the small stuff and the big stuff of our lives to Him with the confidence that *He will speak to us.*

Today, what are areas in which you'd love to hear God speaking to you?

- ☐ Should I continue my education? Where? When?
- ☐ What type of work should I be doing? Should I make a change?
- ☐ What did You, God, create me to do?
- ☐ Is it time to move? Where? When?
- ☐ What's my next step in a relationship: Stay? Leave? Forgive? Mend it? Something else?
- ☐ Should I marry? Who should I marry?
- ☐ Should we have children? When?
- ☐ Should I make this purchase?
- ☐ Should I initiate this hard conversation with someone I love?

You get the idea! Keep going.

- ☐ _____
- ☐ _____
- ☐ _____

Which of these wonderings feels most pressing to you today? Circle it.

PRAY: God, I am offering this to You. Speak, Lord, Your servant is listening.

"Speak, Lord, for your servant is listening." (1 Sam. 3:9)

SOMETIMES WE ACTUALLY HAVE HEARD FROM GOD

Although I can't turn on God's voice the way I can push Play on Spotify, I do remember a moment when I *knew* I heard Him. I was seventeen, heading to a party with my sister and some guys, when God spoke to my heart, and it convinced me that there was a call of God on my life.

As you consider your past, was there a moment when you think that you heard from God? Check the types of experiences that resonate with you.

- ☐ Maybe there was a moment when you heard God as a child but you've written it off as your imagination.
- ☐ Maybe you had a spiritual experience as an adolescent, like I did, when you first heard from God.
- ☐ Maybe you have had a deep knowing inside that you can't explain.
- ☐ Maybe you heard God speaking through someone else, but you knew it was *God* speaking to *you*.
- ☐ Maybe you received a word, a thought, an announcement that you knew you were to speak to someone else.

Take some time to reflect on the moments in your past when you believed that you heard from God. Jot down your specific memories and reflections here.

The first time I heard directly from God, I could have rejected what I was hearing. I could have written it off as my imagination. Years later I could have discounted it as the wild thoughts of a teen. But I didn't. Not only did I *receive* what I heard, I made sure that others knew I'd heard from God too!

Are there any of these memories of hearing God's voice that you want to claim now—in a new way, with more clarity—as having come from God? Reflect on them here.

IF YOU'RE NOT YET HEARING GOD, YOU'RE NOT ALONE

For years I've listened to people a lot like you who have desperately wanted to hear God's voice but could not. And as I've spent this time with God's people, again and again I've heard two big reasons why we struggle.

REASON #1: WE THINK THERE'S ONLY ONE WAY TO LISTEN. We think that hearing from God has to look exactly like it looks for the TV preacher, the inspirational retreat speaker, or a super-spiritual friend. We don't hear because we assume that hearing God has to look like something we don't experience and haven't ever experienced.

REASON #2: WE HAVE OVERCOMPLICATED GOD. This is one reason I'm super passionate about. I'm convinced that we have

made something that's pretty straightforward—hearing from the One who loves us and is always speaking to us—*overly* complicated. We've bought into the lie that our day-to-day life is one thing and *hearing God* is in some other realm completely. But when we look at the Bible, that distinction—between sacred and secular—just isn't there!

Considering these two big reasons that people decide they can't hear God, I want you to take a few minutes to reflect.

When I'm being honest, the *stereotype* of what I think it means to hear God looks something like this:

When I'm being honest, the ways that I separate what I consider *secular* (the everyday stuff of eating, sleeping, shopping, and working) and what I consider *spiritual* (like praying, reading the Bible, and going to church) look something like this:

It gives me so much joy to tell you that you do not need to become "more spiritual" to hear God. And I'm pumped to assure you that hearing God is so much more *uncomplicated* than you've ever imagined!

WHY THE WAY YOU HEAR GOD MATTERS

NINETEEN-YEAR-OLD TYESHA HAD JUST FOUND OUT that her mother had been diagnosed with stage IV pancreatic cancer and likely didn't have long to live. Although she went through the motions of going to school and work, Tyesha was undone. After class one afternoon she wandered through a local park before sitting down on a park bench and weeping.

After about five minutes a wave of calm and peace washed over Tyesha. While she was still sad about her mom's situation, she knew that she was experiencing God's great love for her and her mother. When she stood up to walk back to her dorm room, Tyesha had the confidence that God would continue to care for them both.

Consider the moments in *your* life when you needed God. When have you been unsure if you would make it to the next breath? When have you needed to experience God's nearness?

11

☐ I needed to experience God's presence when someone I loved had an emergency.

☐ I needed to experience God's presence when I lost someone I loved.

☐ I needed to experience God's presence when someone I loved hurt me.

☐ I needed to experience God's presence when I lost my job or someone in my family lost their job.

☐ I needed to experience God's presence when I or my loved ones endured a crisis or trauma.

☐ I needed to experience God's presence when

When we are suffering or in crisis, like Tyesha, God speaks words of comfort to calm our hearts. If we can hear God—and we can!—we can receive that loving care.

WHEN GOD'S CHILDREN SUFFER

When God's people were suffering in Egypt, they were desperate for help. The book of Exodus reports,

> The Israelites groaned in their slavery and cried out, and their cry for help because of their slavery went up to God. God heard

their groaning, and he remembered his covenant with Abraham, with Isaac and with Jacob. So God looked on the Israelites and was concerned about them. (2:23–25)

In essence, God assured His people in this passage, *I hear your cries. I see you. I know your suffering. I feel for you.*

In the following chapter, God involved Moses. To Moses God said once more,

"I have indeed seen the misery of my people in Egypt. I have heard them crying out because of their slave drivers, and I am concerned about their suffering. So I have come down to rescue them from the hand of the Egyptians." (3:7–8)

God repeated, *I see your suffering. I hear your cries. I know, and I'm concerned.*

I am convinced beyond a doubt that God is available to us in these intimate ways. In fact, I believe that God is *always* speaking to us. (I know, I know, it just got crazy!) Specifically, God's constant whisper assures us:

- *I hear you.*
- *I see you.*
- *I care and I feel for you.*
- *I know you.*

I hope you've heard God's steadfast voice speaking those assurances to your heart. If you haven't, I want you to pause and consider when you most needed to encounter God's nearness. Did you experience a traumatic entry into this world when you were born? Did

you endure chaos in your childhood home? Have you suffered other adverse events, like medical or financial crises? Have you or a loved one wrestled with depression or other mental health issues?

I want you to pause to consider the most vulnerable moments on your journey, when you most needed to experience God:

- A moment of emotional crisis when I needed God was

- A moment of physical crisis when I needed God was

- A moment of spiritual crisis when I needed God was

- A moment of financial crisis when I needed God was

- A moment of fear when I needed God was

- Another moment of vulnerability when I needed God was

As you spend time with each of those memories, I want you to quiet your heart and listen for God's voice. Do you hear God saying to you what He said to His children who suffered in Egypt? *I hear you. I see you. I care and I feel for you. I know you.*

PRAY: God, speak Your words to the tender parts of my heart.

"Call to me and I will answer you and tell you great and unsearchable things you do not know." (Jer. 33:3)

GOD IS NEAR, ALWAYS

I want to say that this is *who God is*. God is the one who sees our pain, who hears our cries, who feels for us, and who knows us intimately.

Yes, God is near when we suffer as He was near to the Israelites in Egypt. I also want to suggest that God's present, soothing voice is not available to us *only* when we're bleeding and broken. In fact, we *can* hear God in any situation in which we find ourselves. Yes, we meet God when we're receiving the diagnosis or at the site of the crash or in the emergency room. But we also meet and hear from God in the car and at Target and at the library and at the park. There is no part of our lives from which God is absent.

A lot of my life happens at home and at church. But I know that your life looks different than mine. Where is your body present during a typical week?

☐ My home
☐ Others' homes
☐ My car
☐ Other forms of transportation
☐ School
☐ Work
☐ Church
☐ At the mall or in a store
☐ Restaurants
☐ At the gym or in a group exercise class
☐ Nature
☐ My yard or garden
☐ Attending kids' events
☐ Other: _____

☐ Other: _____

☐ Other: _____

Here's the question: Are you aware of God's presence when you're in *all* these spaces, when you're doing things that don't seem particularly holy? I'm going to cut to the chase and let you know that God is where you are. Did you catch that? *God is where you are.* That means that you don't need to go into a chapel with stained glass windows to hear God's voice or even be down on your knees with your hands folded in prayer. God speaks to you *where you are.*

Close your eyes and imagine God being present with you in each of the spaces where your life *happens* on a regular basis. Spend some time with Him in your heart in those spaces.

GOD IS ALWAYS COMMUNICATING WITH YOU

I'm inviting you to begin to "see" in a different way. To "hear" in a different way. And I want you to know that hearing God, communicating with God, isn't so very different from the ways that you communicate with the other important people in your life. I'm not saying you can shoot God a text and then wait for the chime that tells you He read your message and responded. But I *am* saying that

hearing God is as *common* and as *usual* and as *normal* as hearing from the ones you communicate with daily.

How do you communicate with the people who are closest to you?

☐ Speak face-to-face
☐ Speak on the phone
☐ Holler (Moms, can I get a witness?)
☐ Sign language
☐ Written text
☐ Voice text
☐ Video text
☐ Video call
☐ Direct message on social media
☐ Other: _____

You know how to stay connected to people. And you can make the same daily choices to stay connected to God—in a conversation where you are both speaking and listening.

YOU NEED GOD AT THIS AGE AND STAGE

Each one of us has a different number of voices vying for our attention. My husband, Ben, and I have four sons. When the boys were young, there was a constant stream of words in our home. There were days when I was maxed out! But I know some older adults who live alone and would have loved to listen and chat with one of our little guys.

But let me be plain: When we're lonely and in need of company,

we need to hear God's voice. And when we're surrounded by people, overwhelmed by the voices around us, *we need to hear God's voice.*

Look at this spectrum with feeling lonely and in need of conversation at one end and feeling overwhelmed by the many voices around you at the other. Where do you land on a scale of 1 (lonely and in need of someone) to 10 (overwhelmed by others)? Mark the spectrum with an *X*.

LONELY ——————————————————————— OVERWHELMED
 [1] [10]

While it's natural for the overwhelmed mom to yearn for silence, and also natural for the lonely older adult to yearn for the company of others, *all of us* need to hear the voice of God if we are to *be well.* Whether our days are full of people or void of people, those who experience God's love feel less lonely, less anxious, less fearful, and less stressed.

Pause to consider the many human voices in your life.

- Who do you hear from most frequently? _____
- Who would you like to hear from more often? _____
- Who would you like to hear from less often? _____
- Who is someone you know who does all the talking when you chat? _____
- And who is someone you need to coax into conversation?

- Who's the most mutual conversation partner you have? With whom do you have a good back-and-forth? _____

STAY CONNECTED

We know that a cell phone needs to be plugged in and powered up if it's going to work. If the power in the house goes out or if we're traveling all day without an outlet, our cell phone will die. And the same is true of us.

Jesus said, "I am the vine, and you are the branches. If you stay joined to me, and I to you, you will produce plenty of fruit. But separated from me you won't be able to do anything" (John 15:5 ERV).

You need to be connected to God—hearing from God, being nourished by God's Word—if you are to thrive. In the box, draw how you see yourself being *connected* to God today. Maybe it's a plug in a wall outlet. Maybe it's an apple tree. Maybe it's a pair of AirPods tucked in your ears. This is a chance to notice visually how God might be trying to communicate with you *right now*.

PAUSE TO REFLECT

So many people have said to me, "I can't hear God." Here's the thing: I believe them. Without ever meaning to they've been living a second-class spiritual experience that would tempt anyone to want to give up. Maybe you have been tempted in this way too. If any of the struggles I've described in this chapter resonate with you, I invite you to reflect on a few questions.

> *Could my struggles with anxiety, pain, frustration, and apathy be coming from the same place?*
> *Am I struggling because I'm not plugged in to God?*
> *Could the ache deep inside me exist because of an invisible disconnection?*
> *Could my disconnection to God be leading me to think things that are untrue or to do things I don't want to do?*

Take some time to journal your thoughts on these questions. And remember, this is just for you. You'll get the most out of it if you can be completely honest.

As I think about the quality of my connection with God right now, what I notice is

"This is the way; walk in it." (Isa. 30:21)

LET'S PAY ATTENTION

AT A RECENT CONVERSATION OVER DINNER WITH NEW friends, I listened as each one explained how they hear God.

Trevor reported, "When I walk into a room, I often know what's happening in the Spirit. I just feel it. And I might even look at someone I don't know, and I have a clear sense of what they might be struggling with in that moment."

Jenny shared, "I was riding my bike when four words just kind of rained down from heaven and landed in my head: *I am for you.* Had I seen them on a greeting card? Had I seen them on a license plate? I don't think I'd seen or heard them anywhere, but all of a sudden, they were there."

Charlene explained, "Sometimes I just see a picture that I was totally not thinking about. Like I'll be praying for someone and a picture will come to my mind. And if I stay quiet, God will explain to me what it means."

I was hearing what I already knew to be true: God speaks to each of us in *different* ways.

Maybe you've thought that hearing from God is like a weird super-spiritual out-of-body experience.

Or maybe you've imagined one of those little cartoon angels sitting on your shoulder, speaking audibly into your ear.

Or maybe you thought Jesus might appear in front of your eyes like a hologram.

For me, and for most, hearing God is less like a loud clap of thunder and burst of lightning and more like a whisper. An impression. It's quiet and not shouty. It's soft and not loud.

So what I'm inviting you to do in these pages is to begin by slowing your roll about *what* God is saying and pausing to consider *how* God is saying it to you.

GOD KNOWS YOUR LANGUAGE

God doesn't speak in the same way to everyone. And that isn't because God is a multilingual show-off. The reason God speaks differently to us is because each of us has been uniquely designed to *hear* differently. The psalmist knew this when he wrote, "I praise you because I am fearfully and wonderfully made; your works are wonderful; I know that full well" (139:14).

Over a number of years, as I've listened to God and spent time with people, I've identified four specific modes that God uses to communicate with us. I call them Prophetic Personalities, and they are the personalized filters through which each of us can uniquely listen and speak to God.

If you got freaked out by the word *prophetic*, take a deep breath and settle down. It's not some hocus-pocus superpower that's only given to super-spiritual people. It's actually much more down to earth.

PROPHETIC: How God shows up in your world
PERSONALITY: How you show up in your world

Your Prophetic Personality is simply the way God designed you to develop an intimate relationship with Him. (If you know about love languages, this is your *spiritual* love language God uses to confirm His deep love for you!) The purpose of your Prophetic Personality is so that you can communicate with God.

Before we continue, it's important for you to let go of *any* funky, misguided beliefs that might be interfering with your connecting easily with God. We started this process in chapter 1, and now we're just double-checking to make sure you've let go of any limiting beliefs that might be keeping you stuck.

The ideas I've just discovered that convince me I *can* hear from God are

The thoughts I have that make me *doubt* that I can hear from God are

PRAY: God, thank You for exposing any limiting beliefs I'm carrying that keep me from hearing Your voice. I release each one to You.

YOUR PURPOSE (AND WHAT MIGHT BE KEEPING YOU FROM IT)

Buckle up, I'm fixin' to go deep.

You were made for a purpose. In fact, every person was. (Don't worry, you're still special.) The purpose for which you were made is threefold:

To know God (Matt. 6:33; Prov. 3:5–6)
To make God known (Matt. 24:14; Mark 16:15)
To be known by God (John 10:14)

And if you are to live into this good purpose, we need to make sure you're free of any of the negative beliefs—aka "lies"—that have been keeping you from hearing God. So, one last time, review this list. If any of these beliefs are still in you, stop and ask God to take them.

- ☐ I can't hear God because listening to Him is superhard.
- ☐ I can't hear God because He's unhappy with me.
- ☐ I can't hear God because I've done something to upset Him.
- ☐ I can't hear God because I'm not spiritual enough.
- ☐ I can't hear God because I'm not mature enough in my faith.
- ☐ I can't hear God because I have some kind of learning disability.
- ☐ I can't hear God because I'm not holy or disciplined enough.
- ☐ I can't hear God because I haven't been given the special gift that others have.

☐ I can't hear God because He doesn't speak to *me* like He speaks to others.

☐ I can't hear God because _____

Thanks for hanging in there, friend. I'm really digging in here because I know that these limiting beliefs can keep you from hearing God's voice. But it's not enough to just throw them in the trash. (Though, definitely do that.) What we need to do is to *replace them* with what is truer.

WHAT IS MOST TRUE ABOUT YOU

There are three life-changing truths that are going to replace any of the limiting beliefs that have had their grubby little claws in you. I have prayed and asked God to help you receive these into your deep places. Let them be the food that you chew on, day and night. Internalize them. Digest them. Hold them fast.

1. You are a spiritual being.
2. You were created to know God's voice.
3. God is always speaking to you.

Now let's unpack these truths so that you can be nourished by each one.

You are a spiritual being.

To be a spiritual being means that you have a nonphysical aspect to your existence that connects you to God and the spiritual realm. (You are so much more than your body!)

- Your *body* is the tangible, visible part of you that interacts with the world around you.
- Your *soul* includes your mind, will, and emotions. It's the seat of your personality, where your thoughts and feelings reside.
- Your *spirit* is the deepest part of you that connects you to God. It's where God lives if invited.

Imagine your spirit as a glove. Just as a hand fits into a glove, God's Spirit fits inside your spirit.

PAUSE TO JOURNAL: Dialogue with God, speak and listen. Take some time to reflect on the condition of your spirit. Is God alive in you, in your spirit? Talk to God.

You were created to know God's voice.

For a lot of us, one of the first Scripture passages we may have memorized in Sunday school was Psalm 23: "The LORD is my shepherd . . ." (We might have even glued little cotton-ball sheep onto brightly colored construction paper to show that we are the sheep and God is the Good Shepherd.) When Jesus came to town, He dove deeper, insisting that the sheep follow the Shepherd "because they know his voice" (John 10:4–5). So when you say that the Lord is your Shepherd, you're acknowledging an important truth: you were *made* to hear God.

PAUSE TO JOURNAL: Dialogue with God; speak and listen. Take some time to reflect on the reality that you were made to hear God's voice. *Pause to own it.* Talk to God.

God is always speaking to you.

God is constantly talking to His sheep, even when only a few are listening!

Friend, I need for this to be anchored deep in your core. Let it sink in like a post in cement.

God. Is. Speaking. To. You.

Now.

PAUSE TO JOURNAL: Dialogue with God; speak and listen. Specifically, take some time to reflect on this big idea: "God is speaking to me right now." Spend some time with it. Talk to God.

YOUR MARCHING ORDERS

You don't have to hear God as others do, but you do have to have the guts to show up as yourself. You have to expect that God *is* speaking to you.

He really is.

HERE'S WHERE WE ARE, AND HERE'S WHERE WE'RE GOING

HOW ARE YOU FEELING SO FAR? YOU STILL HAVE energy for this adventure?

We've just spent time discovering that we were each uniquely designed to hear from God. So now I want to introduce you to the four types of Prophetic Personalities: the Hearer, the Seer, the Feeler, and the Knower.

To be clear: what we're *not* doing right now is nailing down which one you are. (You're eager to find out. I know, I know . . .) The reason we're not racing ahead to determine your Prophetic Personality is because there is great value in being familiar with all the types.

So I welcome you to pace yourself and really commit to understanding the four types. It is *so* worth it!

DISCOVER THE HEARER

I WANT YOU TO DEVELOP AN UNDERSTANDING ABOUT and comfort with all four types of Prophetic Personalities for two reasons.

One reason is that your primary type—which you're on your way to discovering—is not the only way that you hear. You can also experiment with the others. While my primary Prophetic Personality type is Knower, when I was seventeen, I received a very clear word from God usually reserved for a Hearer. (God is bigger than our boxes!) Oftentimes we have a secondary or a tertiary way that we hear God.

The second reason I want you to be familiar with the other types is because it helps you know how to relate to others who hear in these ways. For instance, I know that my husband, Ben, is a Feeler and that helps me know how to communicate with him *so that he can hear me!*

So I want to make it plain: this next leg of the journey isn't

a "choose your own adventure" book where you get to zip and skip—zipping forward to what you suspect your type might be and skipping all the chapters in between. Be prepared to receive all you can along the journey. Don't zip. Don't skip.

After this important leg of our journey, however, is when you'll identify your primary Prophetic Personality. That's when I'll give you permission to zip and skip! Hang in there.

———

The first hearing type we're going to explore is, literally, the Hearer.

My twin, Deborah, is a Hearer. Moment by moment she hears God speak to her clearly and verbally. Truly, she gets more downloads before lunch than I do in a month.

So let's look at the Prophetic Personality of the Hearer.

- **HEARERS** receive the voice of God through words, phrases, and sentences.
- **HEARERS** seem to have a direct line to God.
- God's distinct voice interrupts **HEARERS'** thoughts.
- **HEARERS** experience God's words in real time, in a play-by-play style.
- **HEARERS** know precisely what God said, when He said it, and where He said it.
- **HEARERS** have strong confidence in what God has said to them.

- **HEARERS** learn from God through conversations with Him.
- **HEARERS** have a keen sense of confidence in what God is saying.
- Once **HEARERS** activate the word in their life, nothing can stop them.
- Once **HEARERS** hear God speak, they are immediately filled with courage.
- God relies on **HEARERS** to record His words.
- **HEARERS** love to keep a record of things through journaling and/or storytelling.

As you read the qualities of a Hearer, did any of them sound like you? Do you hear God in this way? If so, how?

As you read the qualities of a Hearer, did anyone you know jump to mind? Based on what you're learning about Hearers, who in your life do you suspect might hear God in this way?

When most people think about "hearing God," the Hearer is likely the one who first comes to mind. And in fact, this _is_ the most common Prophetic Personality type. It's the person who reports, "God told me . . ." or "I heard God say . . ." Hearers might even assume that everyone hears God—or could hear God or should hear God—the same way they do. But as you know by now, not everyone hears in this way.

Wondering if you're a Hearer? Review the list and check any of these you've experienced:

- ☐ The voice of God interrupts my thoughts.
- ☐ I hear something that doesn't seem particularly relevant in the moment but I know is important.
- ☐ God gives me a word or phrase for someone else.

While being a Hearer has many benefits, there are some risks as well. Which of these have you experienced?

- ☐ People have unreasonably high expectations of me, holding me to an impossible standard. (If this is you, jot down a specific example.) _____
- ☐ Some have become overdependent on me to tell them what God is saying. (If this is you, jot down a specific example.)

- ☐ I feel a heavy burden to be held accountable for every word I say. (If this is you, jot down a specific example.) _____

WHERE WE NOTICE HEARERS IN THE BIBLE

God gives Hearers a special ability to hear His words and assignments to share them. Here are several from the Old Testament. From memory, what do you know about what these guys heard? What do you know about their assignments?

Noah (Gen. 6–9)
Jacob (Gen. 25–35)

David (1 Sam.; 1 Kings 2)
Jonah (Jonah 1–4)

Now pause to read 1 Samuel 3:1–10, where Samuel was learning to hear from God.

The boy Samuel ministered before the LORD under Eli. In those days, the word of the LORD was rare; there were not many visions. One night Eli, whose eyes were becoming so weak that he could barely see, was lying down in his usual place. The lamp of God had not yet gone out, and Samuel was lying down in the house of the LORD, where the ark of God was. Then the LORD called Samuel.

Samuel answered, "Here I am."

And he ran to Eli and said, "Here I am; you called me."

But Eli said, "I did not call; go back and lie down."

So he went and lay down.

Again the LORD called, "Samuel!"

And Samuel got up and went to Eli and said, "Here I am; you called me."

"My son," Eli said, "I did not call; go back and lie down."

Now Samuel did not yet know the LORD: The word of the LORD had not yet been revealed to him.

A third time the LORD called, "Samuel!"

And Samuel got up and went to Eli and said, "Here I am; you called me."

Then Eli realized that the LORD was calling the boy. So Eli told Samuel, "Go and lie down, and if he calls you, say, 'Speak, LORD, for your servant is listening.'"

So Samuel went and lay down in his place.

The LORD came and stood there, calling as at the other times, "Samuel! Samuel!"

Then Samuel said, "Speak, for your servant is listening."

As you experienced the story of Samuel hearing God's voice, what did you notice? Spend time reflecting on what stood out to you.

Here are several Hearers from the New Testament. From memory, what do you know about these guys' assignments?

Paul (Acts 9:4)
Peter (Acts 11:7–10)
John (the book of Revelation)

When Jesus promised the presence of God would come to His followers after He was gone, He signaled an important change to the status quo. God no longer wanted to speak only through certain individuals, but to each of us. He does this by the gift of the Holy Spirit. The Bible promises the Holy Spirit to everyone who commits their life to Christ (Acts 2:38). Why is this important? Because among His divine roles, the Holy Spirit is the voice of God in your life, consistently allowing you to hear Him speak to you anytime and anywhere.

QUESTION: Doesn't the Bible contain all the words of God? Shouldn't it be all we need?

ANSWER: Yes. And no. I say yes because not only does the Bible contain the words of God, it also holds the essence, nature, and presence of God! And I say no because the Holy Spirit breathes truth and understanding not only into the sacred words of the Bible but also through the unique lens of our Prophetic Personalities.

Wait what?!?!

That means that Hearers receive quickened, specific messages from God, straight from the Holy Spirit. (Pretty big deal, right?)

Hearers learn by listening. So that's what I want you to do. I want you to *practice* by listening to God. Listen for

- a word that helps you make an important decision,
- a word that gives specific insight into someone else's life or situation, and
- a word that confirms God's timing, communication, and love for you.

You might see this word written or hear it spoken by another person in a way that feels significant for you or someone else. Maybe the word is being repeatedly used around you. God's important word will stand out from everything else going on, because it will have meaning for your life. God's voice can stir up your emotions (you might feel peace, overwhelmed, excited, or an urgency to act). These emotions you experience after hearing from God are from God! Pay attention.

PUT IT INTO PRACTICE

It's common for Hearers to be devoted journal keepers. Your journal is an essential tool for affirming your spiritual journey. For you, a journal is more than a diary of what you ate for breakfast and what you bought at Target. Hearers write what they hear from God, confident that it is important—now and/or later.

DISCOVER THE SEER

FOR WEEKS, CYNTHIA HAD BEEN TRYING TO DECIDE whether or not she should keep dating her boyfriend.

There were lots of great things about him: Kyle loved God, he was funny, he was smart, and he loved his mama. But there were also some things about Kyle that Cynthia didn't know what to think about. He didn't make a lot of money, which didn't bother Cynthia. But what did bother her was that he spent a good portion of what he made on lottery tickets and eating out at pricey restaurants. She also noticed that he had a hard time handling his business: whether it was filing taxes or paying his water bill, Kyle let a lot of his responsibilities slide.

Once Kyle brought up the possibility of marriage, Cynthia started asking God to show her whether they were meant to be together. One night Cynthia woke up from a dream with a deep sense of peace and comfort. She didn't remember all the details of what had happened in the dream, but she did remember seeing an image of herself standing on the beach—her favorite place—and

waving goodbye to Kyle as he left on a voyage. Cynthia knew in that moment that her future wasn't with Kyle.

Cynthia is a Seer.

- God speaks to **SEERS** in dreams, daydreams, pictures, images, and visions.
- **SEERS** see the world differently.
- **SEERS** perceive what God is doing and will do, but not necessarily how.
- **SEERS** see things as complete or finished from the very beginning.
- When **SEERS** see something, they envision what is supposed to happen.
- **SEERS'** dreams and visions can be too big to accomplish without God.
- **SEERS** are filled with great faith that what they see will come to pass.
- **SEERS** get a vision that encompasses their passion and motivates them.
- **SEERS** know there are no boundaries around what God can do.
- **SEERS** can see beyond what most people can see.
- **SEERS** have supernatural ideas and solutions.
- **SEERS** see what heaven sees and have an aerial view of God's purpose.

As you read the qualities of a Seer, did any of them sound like you? Do you see God in this way?

As you read the qualities of a Seer, did anyone you know jump to mind? Based on what you're learning about Seers, who in your life do you suspect might see God in this way?

Wondering if you're a Seer? Check the list and see if you've experienced any of the following:

- ☐ God shows up in my world visually—through mental images, dreams, visions, and even daydreams. (Hint: they may not always seem supernatural or even spiritual!)
- ☐ God shows me things to reveal His nearness in my life.
- ☐ I see things as they should be, not only as they are.
- ☐ I have an eye for the future.
- ☐ I love to dream big.
- ☐ I can inspire others to see what is possible and stir them to action.
- ☐ I see with spiritual eyes what God is doing or will do.

While being a Seer brings many benefits, there are some risks as well. Which of these have you experienced?

- ☐ Others might not find my perspective easy to understand or accept.
- ☐ Sometimes it's difficult to explain what I see or why it matters.
- ☐ It's hard to get people on board with my big ideas.
- ☐ I sometimes feel as if no one listens to me.

WHAT WE SEE IN SEERS

Seers envision destinies and dream big dreams. They love to strategize with the Lord to bring their vision to pass. They're captivated by the possibilities of what could be. They may even have prophetic dreams and visions—foreknowledge of specific events.

Can you think of a time when you saw a big dream but others didn't see what you saw?

If you're a Seer, or if you're another Prophetic Personality, perhaps you've already experienced moments of seeing. Do any of the following prompts call to mind a time when God spoke to you by *showing* something to the Seer in you?

- ☐ "Now I see it!"
- ☐ "This is where I'm going and what I'm doing!"
- ☐ "This is what I'm building."
- ☐ "This is what I'm destined to do."
- ☐ "This is my purpose."
- ☐ "I know exactly where I'm going and I'm not changing direction."

If any of these resonate with you, say a little more about that experience here. What was happening? What did you see? How did you respond?

The Seer is also known for having unique pictures and perspectives about people and situations. He or she is often good at making connections between different ideas or concepts that other people might not see. The Seer is especially adept at seeing patterns in life, relationships, and nature; you may see what others miss entirely.

Can you think of a time when you experienced

- bringing a unique perspective to a situation,
- making connections between ideas/concepts that others missed, or
- seeing a pattern in life, relationships, and nature that others missed?

If you've experienced any of these, say a bit more.

WHERE WE NOTICE SEERS IN THE BIBLE

In the Old Testament, Samuel and Gad were Seers, which meant they could see with spiritual eyes what God was doing and what

He would do. They had a spiritual gift for perceiving the meaning of things that were unknown to everyone else. They perceived the hidden truth (1 Chron. 29:29). Here are several others:

- Jacob dreamed of a ladder stretching up into heaven (Gen. 28:12).
- Joseph, the son of Jacob, dreamed of his future (Gen. 37:1–10).
- Solomon asked for wisdom in a dream (1 Kings 3:5–9).
- Three times God appeared to Joseph, the earthly father of Jesus, in dreams (Matt. 1:20; 2:13, 19–20).
- People who had visions of heaven include Paul (2 Cor. 12:2), Stephen (Acts 7:55–56), and John (Rev. 1:12–16).
- God used visions to tell Paul where to go (Acts 16:9).

While some people believe that dreams and visions are some kind of super-spiritual communication that God used *only* back in Bible days, I'm not one of them! I know for sure that God still speaks in dreams and visions today.

As you look at these six biblical examples (and there are so many more!), do they jibe with anything that either you or other modern believers you know have experienced?

Write down some modern examples of people receiving insight from God through dreams and visions.

KEEPIN' IT REAL

Sometimes we miss what God might be saying to us in any moment because it's not what we're expecting. God is communicating with us, but we're missing it. Several years ago when I was preaching, I saw a picture of a piece of paper where the word *report* had been crossed out. And for whatever reason, the Holy Spirit impressed *three days* on my heart. Now, I could have ignored whatever weird thing was happening to me, but instead I reported it to the congregation.

"I feel like the Lord wants you to know that the reports are being canceled in the next three days." Then I saw a hand with rings on it. I said, "I see people are getting engaged in the next three days. People are getting jobs in the next three days. Things are coming to fruition in the next three days."

It wasn't something I was expecting—at all—but when it came, I shared it. And the response? Huge! That vision resonated with many people, and they received what God had for them in that message.

Ask God to bring to your mind a time when He was trying to speak to or through you and you ignored or dismissed Him. Reflect on that experience.

BEING A FAITHFUL STEWARD

The way we grow in hearing God's voice is by *practice*. Specifically, we learn by taking risks. When God speaks, we must be willing to look a little foolish or not have all the answers, as we receive what He says for ourselves or others. Yes, I know, that takes courage! But God's promise to Joshua is also God's promise to us today: "Have I not commanded you? Be strong and courageous. Do not be afraid; do not be discouraged, for the LORD your God will be with you wherever you go" (Josh. 1:9).

Here's how to live that courage:

- Be bold and share what you receive with others.
- Pay attention to the picture, word, or phrase you notice. Receive it!
- When you notice a deep desire to pray for someone, pause and make it happen.
- Honor any dream you have about someone or yourself. Or ask God to reveal the meaning to you.

Be mindful, though, that sometimes others may not pick up what you're putting down. And I want you to know that that's *okay*. Your job is simply to humbly deliver what God has given you.

I need you to know that practicing and taking risks is actually the *only* way to confirm whether or not you're hearing God accurately. So be brave. When you're faithful to risk, to practice, to obey, you're going to develop a rich history with God that trains you to recognize His voice.

When have you taken a risk to share something God has given you?

SEERS SEE WHAT'S NOT THERE

God showed Cynthia in a dream that she wasn't supposed to marry her boyfriend. Other times, God will show Seers something that doesn't yet exist. Maybe it's a home that a family hasn't yet come across. Maybe it's a successful enterprise that doesn't yet exist. God gives Seers the vision to see what others can't.

Who do you know personally or who is someone you've read or heard about or someone from Scripture who had faith and hope for the impossible because God had shown it to them? List as many examples as you can.

PUT IT INTO PRACTICE

Do you remember the dreams you have at night? Neuroscience tells us that visual imagery is one of the most efficient communication tools. We're just better at understanding pictures than we are at written or spoken words. And the Bible confirms that dreams can be strong channels of communication from heaven.

- Have you ever had a recurring dream? What was it? _____

- Have you ever had a dream that stuck with you or that you suspected was particularly meaningful? What was it? _____

- Have you had a dream in which you received an answer to a question, a solution to a problem, or a word of hope for a hopeless situation? What was it? _____

KEEP GOING: If you'd like help paying attention to your dreams and receiving what they have to tell you, I believe that you can train yourself to catch them if you leave paper and pencil beside your bed and grab them in those first moments of waking up. Try it!

CHAPTER 6

DISCOVER THE FEELER

SARAH, AN ATTORNEY IN HER MIDFIFTIES, SHARED what happened to her recently. "I had to go to the mall to get a dress for my cousin's wedding, and I was in a hurry. I had a thousand things on my mind, but when I entered one store, an upscale boutique, I was overcome by a feeling of deep sadness."

Sarah took a deep breath before continuing. "There was only one person in the store, the clerk. She approached me and asked if she could help me. I'd seen a dress I liked, so I took it into the dressing room. When I was in there, I asked God what the *sadness* was about. He told me that the woman in the shop had just suffered a deep loss and that He loved her. And although it was super awkward, when I paid for the dress, I told her that God knew she was hurting and He loved her. She burst into tears and shared her story with me. It was a trip!"

Sarah is a *Feeler*.

So let's look at the Prophetic Personality of the Feeler.

- God speaks to **FEELERS** through emotions and sensations.
- **FEELERS** have unusual sensitivity to their surroundings.
- **FEELERS** sense what God is saying by experiencing His emotions.
- **FEELERS'** emotions give insight into what's going on in the heart of God.
- **FEELERS** perceive spiritual nuances that most people miss.
- **FEELERS** can't explain why they feel something; they just do.
- God interrupts **FEELERS** through their emotions so they can partner with Him.
- A mature **FEELER** can feel something without being overcome by it.
- **FEELERS** carry what they feel with them.
- **FEELERS** are powerful intercessors.
- **FEELERS'** emotions connect to the mystery of God's heart, motives, and emotions.

If you're a Feeler like Sarah, God likely speaks to you through the spiritual conduit of intense emotions. And it's possible no one ever encouraged you to recognize that what you experience and the emotions you feel are gifts from God. It's even possible that others have made you feel extra because you *do* have big feels. So I'm delighted to report that not only is the way that you're wired *good*, but it may be exactly the way God is speaking to you.

Do you have any of the qualities of a Feeler?

☐ I am particularly sensitive to noticing the presence of God.
☐ I feel things others don't feel.

- ☐ I can perceive how someone else is doing—emotionally or spiritually—without their telling me.
- ☐ I'm keenly aware of my surroundings.
- ☐ When I enter a room, I can sense a positively or negatively charged atmosphere.
- ☐ Sometimes I just *know* when a place doesn't feel quite right.
- ☐ I notice things others may not notice with their physical senses.
- ☐ I catch nuances most people miss.

Some people assume that most Feelers are women. (Feel free to imagine that really dramatic woman who makes others uncomfortable because she is *so* expressive with her emotions.) But being a spiritual Feeler doesn't have anything to do with causing a scene in a restaurant because there was a bug in your soup. Being a Feeler isn't about your feelings at all: it just means you experience God's voice through a heart connection. You experience God through your emotions.

WHO FEELERS ARE AND WHO THEY'RE NOT

Do you know anyone who is super expressive and emotional and gets overwhelmed by their big feelings? List anyone you know (including yourself!) who fits this description.

Do you know someone who's wired like the *spiritual* Feeler and

is very sensitive to God, to people, to environments? List anyone you know who you suspect might hear God as a Feeler.

My dad—a true Feeler—may pass someone in public and just know that he has to speak to them. He feels God's heart frequently and is always willing to share the word or words he feels God wants him to deliver.

Have you ever felt a deep tug to stop and speak to someone you didn't know? Recall a time when you felt a tug to speak to someone and ignored it.

How about a time when you paused to speak to a stranger because you felt an inner pull toward them?

Sometimes Feelers are "interrupted" by God via their emotions. Has that happened to you?

A time when I suddenly sensed a deep sadness or heaviness—
unrelated to what was happening in the moment—was

Did you respond to this emotional awareness? Why or why not?

A time when I suddenly sensed a deep peace or joy—unrelated
to what was happening in the moment—was

Did you respond to this emotional awareness? Why or why not?

If you're wired as a Feeler, if you're someone who doesn't ignore or
dismiss their emotions, it's possible that others—who are wired dif-
ferently than you are—have made you feel as though you're broken.

As though there's something wrong with how you are. And that's why it's really important to me that you hear this clearly: how God made you is just right!

Still wondering if you might be a Feeler?

Reflect on a time when someone told you your feelings were too much. Did you fear they might be right?

What do you think of the possibility that, no matter your type, how you are is *exactly* right and it's actually how God speaks personally to you?

GOD MADE US TO FEEL

The fact that feelings are a *good gift* from our Maker isn't my big idea. In fact, the Gospels show us that Jesus—who was inexplicably fully God and fully human—felt the same range of human emotions that we feel. When His friend Lazarus died, Jesus wept (John 11:35). When shysters were taking advantage of devout people at the temple,

Jesus was so angry that He turned over the tables of the money changers (Matt. 21:12). In the garden of Gethsemane, on the night He was betrayed, Jesus endured grief and distress (Matt. 26:37). Everything we feel, Jesus felt.

Because our culture can be dismissive of feelings, I need you to know two things:

Your emotions have no moral value.

If you had parents or caregivers who were afraid of their own emotions (likely for some good reason), they may have wanted to squash *your* emotions. They might have barked, "Well, you don't have to get *angry* about it." Or "Don't feel *sad*." Or "There's no reason to be *scared*." They acted as if our feelings were *bad*. But feelings aren't good or bad; they just *are*.

Was there anyone in your life who made you feel like your feelings were bad? How? How did you respond?

Your emotions are signals.

Emotions truly are a good gift because they give us insight into ourselves and what's happening around us. When something is unjust, we feel angry. When we endure a loss, we feel sad. When we're in danger, we feel afraid. And when we're experiencing joy, we feel happy! But without emotions the injustice, the loss, the danger,

or the joyful experience could slip right past us. Thankfully, our emotions signal where we can and should pay attention.

Do you receive your emotions as a good gift, or are you tempted to resist them? Say more.

Some of the people I care about most in this world are Feelers: my dad is one; Ben, the love of my life, is one; and my former assistant, Tiffany, is one. When Tiffany would be with me when I was preparing to speak, I'd ask her to "read the room" for me. I'd want her to tell me what she was feeling or sensing in the room. What a gift that was! Her insights helped me view situations in new ways.

Who is someone in your life who seems to be a Feeler and hears from God through his or her emotions?

Maybe you're not preparing to speak onstage, but as you think about your particular perspective—as a teacher, parent, medical professional, cashier, or other—how might you be able to glean from what your Feeler friends have to offer? Pause and listen, noticing what comes to mind.

FEELERS AS INTERCESSORS

One of the things we know about Feelers is that they have a unique call to pray on behalf of others. They're called to be intercessors. If you think about it, it really makes sense: Feelers can feel the burden of sensing a lot around them, and that could be overwhelming, especially if they are confused about which emotions belong to God, which belong to them, and which belong to someone else! So intercession is a strategy to help release those emotions.

PUT IT INTO PRACTICE

Recall a recent time when the emotion you were carrying felt big: anger or sadness or fear or disappointment or anxiety or something else.

The big feeling I experienced recently is _____.

Now spend some time in prayer, sharing that experience with God. What do you notice? What is God showing you about what you experienced?

KEEP GOING: The next time you experience a big emotion, whether or not you can connect it to a current moment, offer it to God and open yourself to receiving insight from Him.

DISCOVER THE KNOWER

JACKSON WAS ON THE BASEBALL TEAM FOR HIS LOCAL community college. One day in the locker room after practice, he noticed that one of his teammates was taking longer than others to get dressed. Suddenly, Jackson knew that this young man's parents were getting a divorce. He'd never even had a real conversation with this guy, but somehow, he just *knew*. When Jackson quietly asked God about it, God coached him not to mention it to anyone, and to pray for that teammate. And Jackson obeyed.

Jackson is a Knower.

- God speaks to **KNOWERS** through intuition, wisdom, and clarity.

- **KNOWERS** receive the voice of God through a strong but undefined sense.
- **KNOWERS** have a spiritual sensitivity distinct from their emotions and physical senses.
- A **KNOWER'S** faith life is rooted in instinct rather than in feeling or thinking.
- **KNOWERS** are as spiritual as anyone else but might worry they are not.
- **KNOWERS** can't always explain how they know; they just do.
- **KNOWERS** lead with clarity, conviction, and wisdom.
- **KNOWERS** often know the best way forward.
- **KNOWERS** are commonly right about the way something will turn out.
- **KNOWERS** possess an internal light bulb that illuminates aha moments.
- When **KNOWERS** ask God, they immediately receive clear direction.
- Other people often seek out **KNOWERS** for their wise insights.

I'm going to go out on a limb here and say that the Knower is the most misunderstood of the four Prophetic Personalities. You probably won't hear them saying "I heard" or "I saw" or "I felt." So it's harder for those around them to discern that what they're receiving is from God.

Do you have any of these qualities of a Knower?

- ☐ I don't experience God through my physical senses or emotions.
- ☐ I typically don't have visions or hear from God in dreams.
- ☐ I don't hear God speak in words or sentences.

☐ I often don't *feel* God's tangible presence.

☐ For a time, I didn't believe I heard God's voice.

☐ Even though I read my Bible and am growing in my faith, I question the authenticity of my spiritual experience.

☐ I sometimes feel "unspiritual."

☐ I'm not always connected to my emotions.

☐ Others think of me as someone who has good ole common sense.

KINDS OF KNOWING

One kind of knowing is natural intuition—having knowledge of something without evidence or reason. The other kind of knowing is *supernatural* intuition. That's when your intuition is rooted in the Holy Spirit. Yes, you still know it in your gut. But your gut is being guided by God's Spirit!

Can you think of a time when you just knew in your gut that something was right or wrong? Write it down here.

And now, can you think of a time when your "gut instinct" was clearly *guided by God*? Describe that experience.

BIBLICAL KNOWERS

I want you to consider some of the Knowers in Scripture. See if any of these quicken your heart or bring to mind times when you experienced a deep "knowing." Or maybe they remind you of someone who might be a Knower.

Joseph interpreted Pharaoh's dreams and showed Egypt how to survive during the famine (Gen. 41).

In what situation, if any, have you instinctively known the right strategy to help others flourish?

Is there anyone in your life who seems to perceive, to know, like Joseph?

Elisha's knowing led him to instruct the Israelites to dig ditches to capture the water God provided (2 Kings 3).

In what situation, if any, have you instinctively known how to access what God has given?

Is there anyone in your life who seems to perceive, to know, like Elisha?

Paul's knowing could have saved a ship full of people from avoiding a life-threatening situation if the officers had listened (Acts 27).

In what situation, if any, have you known and shared a course of action but others rejected it?

Is there anyone in your life who seems to perceive, to know, like Paul?

Jesus perceived the thoughts of those near Him who were thinking of evil (Matt. 9:4).

In what situation, if any, have you been able to know what others were thinking, without explicit evidence from your senses?

CREATED TO HEAR GOD JOURNAL

Is there anyone in your life who seems to perceive, to know, like Jesus?

LIGHT BULB MOMENTS

Have you ever seen a cartoon where a character has a sudden insight and a light bulb shines brightly above them? A Knower might be going about their day when they suddenly become aware they are having a "light bulb moment."

- "I'm supposed to do this."
- "I need to contact this person."
- "This is the answer to that particular dilemma."
- "I believe God wants me to do this."
- "I don't know why, but this is the right thing to do in this situation."

As you consider each of these types of light bulb moments, record any that resonate with you. Describe times when you recall thinking or feeling this way.

Sometimes when Knowers receive these kinds of "downloads" from God, there is a strong sense of urgency that accompanies the knowing.

Have you ever perceived that there was a particular time frame that accompanied your strong sense of what to do? Describe it.

IT DOESN'T MAKE SENSE

Sometimes Knowers have a *sense* about something—that just doesn't make sense! It may be hard for those around them to understand, and it may be hard for the Knower to understand. But as you begin to look for, identify, and receive that inner leading, you'll grow in your ability to hear.

Have you ever known something, or perceived it, without being able to explain why? Describe that specific moment and how you responded.

Answer one of the follow-up questions.

- If you joyfully and wholeheartedly received this "knowing," what happened?
- If you hesitantly and half-heartedly received this "knowing," what happened?
- If you thoroughly and wholeheartedly *rejected* this "knowing," what happened?

Now I want you to consider this possible scenario. You are presented with an opportunity to sponsor a child overseas, and you have a hunch that it has your name on it. Use your imagination to consider,

- *If I joyfully and wholeheartedly receive this "knowing," what might happen?*
- *If I hesitantly and half-heartedly receive this "knowing," what might happen?*
- *If I thoroughly and wholeheartedly reject this "knowing," what might happen?*

Is there a key takeaway for *you* from the exercise? Name it.

TRUST YOUR SPIRITUAL GUT

Whether you're a Knower or one of the other Prophetic Personalities, each one of us has a spiritual gut.

What's one example of an opportunity to move forward by heeding and obeying what you hear with your spiritual gut?

And what's one example of an opportunity to step back or stop something by heeding and obeying what you hear with your spiritual gut?

Believe me when I say that I am not in the regular habit of prophetic parenting. But one day I did know simply that God wanted me to talk to my son, sensing that there was something he needed to share with me. While it absolutely felt a little awkward at first, we both ended up convinced that God _had_ given me that little nudge. I know firsthand that it can just feel weird. But as we learn to recognize those little nudges, we can learn to say yes.

When was a time in your life that you felt a holy little nudge and took a risk to act on it? What was the result?

When was a time that you felt a holy little nudge and chose not to act on it? What was the result?

If this possibility of responding to a deep spiritual knowing feels new to you, I get it. And I want to encourage you to pay attention to that inner knowing, to God's prompting, with a curiosity to wonder if it's from God and a willingness to say yes.

PUT IT INTO PRACTICE

Sometimes we *have* heard God speaking to us, but we chose not to listen. (Ouch!) Could you finish any of these sentences?

- I knew I shouldn't have _____, but I _____.
- God told me _____, but I _____.
- I was aware that Scripture says _____, but I _____.
- I heard _____, but I _____.
- I did have the sense that _____, but I _____.
- I knew that I should have _____, but I _____.

You get it. Now write your own.

If you're able to identify a time when you likely *did* hear God but chose to ignore or dismiss a word you didn't like, offer that to God now. Use the space to talk to God about it.

If you're a Knower, I need you to hear that just because you can't offer proof or evidence for what you know, you are still hearing from God. So begin to practice saying yes to your spiritual gut and grow in your unique ability to hear God.

HERE'S WHERE WE ARE, AND HERE'S WHERE WE'RE GOING

YOU'VE LEARNED ABOUT THE PROPHETIC PERSONALITY types, and it's almost time to identify yours!

Before we do that, I want to get you in the mood. I want you to begin considering which of the four types seems most like who you are. (You've already been doing this on our journey, I know.)

After this next chapter, which will help you consider the ways you already experience God, I'll invite you to take a quiz to determine your type.

CONSIDER YOUR TYPE

IF YOU HAD TO GUESS RIGHT NOW, WHAT WOULD YOU say your primary Prophetic Personality type is?

> Based on what I've learned so far, I suspect my primary Prophetic Personality type is _____.

If it wasn't entirely obvious to you or if you had to really pause to weigh the different types, you're in good company. I meet a *lot* of people who hear from God in a variety of ways. I think it's helpful to compare this to the ways people learn: people can be visual, auditory, tactile, or experiential learners, but most find that *one* of these is the best way for them to learn.

If you had to venture a guess, what would you say might be the Prophetic Personality types of those who are closest to you? (No pressure. No one's grading these. No one needs to know. Just make your best guess.) Consider your spouse, parents, grandparents,

siblings, children, close friends, coworkers, and any others with whom you're close.

When I introduced "Prophetic Personality" in chapter 3, I offered a twofold definition:

PROPHETIC: How *God* shows up in your world
PERSONALITY: How *you* show up in your world

And while I don't want to pull the proverbial rug out from under you, there's actually more. (Sorry, not sorry.) What I'd like to add is this third part:

PROPHECY: How God shows up in the world *through* you

This part is really important to me because sometimes what God is speaking to us is for us and sometimes it is for us to offer to someone else. And I believe that God is faithful to make it plain to you which is which.

WHY IT MATTERS

I am passionate about these Prophetic Personalities because your particular personality is God's primary way of speaking love and direction into your life.

Wait, wait, did you catch that? Love and direction? Yeah, this isn't just about God giving you a to-do list of assignments. No, there is so much richness for you as you learn to hear God's voice.

Love

I believe that every heart is hungry to know that they are loved.

Right now, in this moment, what does your heart yearn to hear from the Lover of your soul?

Direction

I don't believe God saved us through Jesus just to disappear and then give us a high five when we reach the pearly gates. No, God longs to offer us guidance and direction day by day, moment by moment.

Right now, in this moment, what are you wanting and needing to receive direction or discernment about?

Can you see why I'm so psyched about this? When you live in this kind of connected, authentic relationship with God—where you receive His love and direction—anything is possible!

DISCERNING YOUR TYPE

Even though you might hear from God in different ways, you do have a primary type. And while I'll be offering you a tool to identify

that type, there are some warm-up questions you can ask and answer that will likely point you in the right direction.

How does God speak to me (rather than through me)?

It's possible that when God is speaking through you, offering something for you to share with someone else, it won't be through your *primary* Prophetic Personality type. (Imagine the pastor prepping for Sunday morning. The word God has for the pastor's congregation might be different than the word He has for the pastor personally.)

When God is *speaking to me*, how do I hear? Spend some time reflecting on this.

How did God speak to me at the beginning of our relationship?

When you consider how God got your attention in the first place, causing you to believe He was real, what encounters did you have with Him?

As I consider the *beginning* of my relationship with God, I can pay attention to our communication and connection. Spend some time reflecting on this.

Have I focused so much on how God speaks to others that I've allowed myself to become discouraged?

If the place where you worship God has elevated one Prophetic Personality type above the others—especially when it's not yours—you may naturally feel discouraged.

As I consider the way the various types are esteemed in my spiritual community or by those I respect, here's what I notice:

And when I lean into God and ask Him to guide me into His will for me, here's what I notice:

What has hurt me most deeply?

While I know it may feel hard to hear, what hurts you most can be a clue to your Prophetic Personality. I want you to consider these four ways that the various types can experience hurt and see if any resonate with you.

- If you've experienced the most pain in feeling left out of spiritual things, maybe you're a Knower.
- If you've been devastated by your emotions, it could be evidence you're a Feeler.
- If you've had big dreams that feel impossible to explain and might even have been dashed, maybe you're a Seer.
- If you've ever felt used or exploited for your spiritual perception, perhaps you're a Hearer.

As you consider these four types of hurts, spend some time reflecting on the one that resonates most deeply with you.

In light of these four kinds of hurts, one that comes to mind that is particularly painful for me is:

And this kind of hurt makes me think my type could be:

Spend some time discussing this with God.

What do I need most from God?

Identifying what you're looking for—because of how God created you—can also give you clues about your Prophetic Personality.

- Are you looking for a feeling of being loved and connected? You might be a Feeler.

- Are you looking for more confidence and clarity? You might be a Knower.
- Are you looking for an open conversation so you can ask Him questions? You might be a Hearer.
- Are you looking for a vision or a clear picture of your future? You might be a Seer.

Which one of these needs—or hopes or wants or desires—resonates most with you? Take some time to reflect on what this might tell you about your primary Prophetic Personality type.

How do I communicate God to others?

You can also discern clues about your type by noticing how you prefer to communicate God to others.

- Do you want people to have an emotional experience with God? You might be a Feeler.
- Do you want others to know the truth? You might be a Knower.
- Do you want others to hear God speaking directly to them? You might be a Hearer.
- Do you want others to see God with the eyes of their hearts? You might be a Seer.

Does one of these preferences resonate with you? Which one? Circle it.

STILL FEEL STUCK?

Do you still feel unsure about your type? Whether you've been communicating with God for so long that it's hard to say which makes you feel most connected or you've felt disconnected from God for a while, I know this process can feel unwieldy.

Here are three more strategies as you consider your type:

1. I encourage you to *return* to question 2 on page 76 and continue to reflect on your experience of falling in love with God—even if, since then, you've wondered if what you experienced was real! The way that God communicated with you then can give you wonderful clues into how God communicates with you today.

2. You can also ask someone close to you for their insights. "When I talk about God, what phrase do I use the most? 'I know,' 'I feel,' 'I heard,' or 'I saw'?" If they don't know, ask if you can talk about your first encounter with God or a painful experience you had and see if you can pinpoint your type together.

3. Make note of your experiences this week, especially any moments in which you were aware of God.

 - Did a particular song speak to you?
 - Did someone say something to you about God that stuck with you?
 - What about a passage from a sermon, your Bible reading, or even a social media post?
 - When were you aware of God this week? What was it that connected with you?

When you know how God communicates with you as one who He made on purpose, exactly as you are, then you are fully equipped to live well and pursue your goals.

And now, drumroll please . . .

HERE'S WHERE WE ARE, AND HERE'S WHERE WE'RE GOING

IT'S TIME! IT'S TIME! RIGHT NOW, IT'S TIME TO TAKE the quiz!

Answer each question by marking either the True box or the False one.

1. I get an overwhelming feeling of what's going on in the atmosphere when I enter a physical environment.
 ☐True ☐False

2. I operate on instinct and intuition.
 ☐True ☐False

3. I have a strong inner voice that guides me.
 ☐True ☐False

4. I tend to have big dreams.
 ☐True ☐False

5. I have trouble functioning when things don't "feel" right.
 ☐True ☐False

6. I find it easy to push through barriers and overcome obstacles.
 ☐True ☐False

7. I tend to enjoy journaling and keeping track of my life.
 ☐True ☐False

8. I struggle waiting for my dreams to happen.
 ☐True ☐False

9. I have often been labeled "overly emotional" or "too sensitive."
 ☐True ☐False

10. I tend to struggle communicating why I have a strong faith about something.
 ☐True ☐False

11. I tend to enjoy working alone.
 ☐True ☐False

12. I tend to envision how things should be done in a particular situation.
 ☐True ☐False

13. I pick up on other people's emotions.
 ☐True ☐False

14. I tend to have inspired thoughts interrupt my own thoughts.
 ☐True ☐False

15. I struggle focusing on details.
 ☐True ☐False

16. I struggle relating to others who don't envision what I do.
 ☐True ☐False

17. I am able to feel things others do not.
 ☐True ☐False

18. I tend to be a person with unwavering faith and trust.
 ☐True ☐False

19. I learn by listening to others speak.
 ☐True ☐False

20. I would rather be dreaming about the future than focusing on today.
 ☐True ☐False

SCORING THE QUIZ

For every question that you answered True, circle the corresponding word in the list provided.

For example, if you answered False for the first question, True for the second, and False for the third, you'd only circle the word after #2—because you answered it as True.

1. Feeler
2. (Knower)
3. Hearer

Now, comparing your answers to the list below, circle each word that corresponds to a question you answered True.

1. Feeler
2. Knower
3. Hearer
4. Seer
5. Feeler
6. Knower
7. Hearer
8. Seer
9. Feeler
10. Knower
11. Hearer
12. Seer
13. Feeler
14. Knower
15. Hearer
16. Seer
17. Feeler
18. Knower
19. Hearer
20. Seer

Now, tabulate how many of each type you circled . . .

Hearer ____
Seer ____
Feeler ____
Knower ____

The type with the highest number (whether it's 1, 2, 3, 4, or 5) is your Prophetic Personality type!

My Prophetic Personality type is _____

You discovered your type!
Were you surprised? How does it feel? Does your type resonate with you? What questions do you have? Journal your thoughts.

Now *this* is where this reflection journaling guide turns into a "choose your own adventure" book! At this point, I want you to turn to the chapter that is going to help you explore and develop your unique Prophetic Personality.

Q: Havilah, do I just skip the other chapters?!
A: I hope you won't. I hope you'll read them and learn from them! I also encourage you to learn *lots* more by reading *Created to Hear God: 4 Unique and Proven*

Ways to Confidently Discern His Voice. Just know that you'll be doing the most intense personal work in the chapter that helps you explore your unique Prophetic Personality.

If you scored as a *Hearer*, turn to page 89.
If you scored as a *Seer*, turn to page 99.
If you scored as a *Feeler*, turn to page 109.
If you scored as a *Knower*, turn to page 121.

Keep going!

DEVELOP THE HEARER

SARAH SPENT A LOT OF TIME IN PRAYER, READING THE Bible, and memorizing Scripture. In her devotional time with God, Sarah would listen for God's voice and write down what she heard. Sarah went on to share some of what she heard in her book *Jesus Calling*. It has sold more than forty-five million copies worldwide. You may have heard of her. Her full name was Sarah Young.

Sarah was a Hearer.

If you're a Hearer, I want you to begin to imagine what God might want to do through you. At the salon. In a restaurant. At the grocery store. On an airplane. At the bank. In fact, I want you to be in conversation with God about it. Welcome whatever it is that God wants to say to you.

What could God do through your life because you can hear Him?

CREATED TO HEAR GOD JOURNAL

Can you think of any messages you've received in the past that may be direct assignments God has given you to give to others?

Who might be waiting for you to bring them a message of hope?

A REFRESHER

If you've discovered you're a Hearer, congratulations! Now that you know how God is likely speaking to you, you can devote yourself to becoming a good listener.

Let's review what it means to be someone who hears from God as a Hearer:

- God shows up in your world through words.
- He uses phrases, sentences, conversations, and stories to speak to you.
- You encounter the voice of God through a play-by-play experience.
- You're the one who can pinpoint what you heard God say, when He said it, and how it affected you.

What is true of every Prophetic Personality, including yours as a Hearer, is that your strengths are an outgrowth of your relationship with God. They don't *create* your relationship, but they are supernatural benefits of a healthy and intimate relationship with your Creator. So as you continue to nurture your personal relationship with God, you will grow in your ability to hear.

I want to equip you to be faithful to use your gifts as a Hearer, and in order to be a good steward of the unique way you're made, you need to be aware of both your strengths and your weaknesses.

STRENGTHS OF A HEARER

As I share with you a bit of what we know about Hearers, I welcome you to reflect on where you've noticed this type of experience in your own journey—even if you didn't receive it as God's voice at the time!

Hearers have a unique ability to hear the voice and thoughts of God.

God speaks to you in clear words, phrases, and conversations. (You can see why others may envy this!) Whether it's a quiet whisper or a phrase that lands in your heart with a thump, you receive the words God speaks as something clearly outside of you.

As you consider your experience, when was a time that you heard a specific word or phrase from God? What did you do with it?

Hearers can point to the specific moments when they heard God.

Whether it's a brief moment at the mall food court or a message you received from God while swimming in the ocean, you can pinpoint the times that God spoke clearly to your heart and mind.

As you consider your experience, notice the times and places when you know you heard God speak. Record them here.

Hearers can independently receive and protect the word they've heard from God.

When you hear from God, you *know* it's God, and that's all you need. And you know how to keep that word safe. That means you hold it close and let it guide the decisions you make.

As you consider your experience, when have you received a word that you knew was from God, even when others might not have believed what you heard?

Hearers can document their history of God speaking and reveal it at the right time.

Part of protecting the words God gives is capturing them: writing them down or recording them in some way. You hold God's

word with care until it's time to reveal it. Ask God to help you be a faithful steward of what He has entrusted to you.

As you consider your experience, when have you received a word that you needed to hold with care until you were released to share it?

Hearers can break open the barrier between the visible and invisible worlds.

When you are faithful to share what God has given you, God's word can land in the heart of another in such a way that it creates a crack between the natural and the supernatural. It shines a light into previously dark places.

As you consider your experience, when did you see that barrier between heaven and earth, between the natural and the spiritual realms, open up?

WEAKNESSES OF A HEARER

Just as it's important to notice the unique strengths that Hearers possess, you'll also benefit if you can be aware of the weaknesses and temptations that are unique to Hearers.

Hearers can't always see the big picture because they get stuck in the details.

While it's great that you are hearing clearly what God is saying, it's important to remember that while the pieces you're being given are gifts from God, you may not hear *everything*. You may be tempted to share what you've heard as if it's the whole picture, which could be misleading.

TEMPTATION: You may be tempted to obsess over details, rather than just deliver what you've been given.

PRACTICE: Commit yourself to practicing humility. Ask God for help.

JOURNAL: Take some time to journal with God in your personal notebook: confess this temptation in your life and solidify your commitment to practice humility. Then listen and record what you hear here.

Hearers can overwhelm people with the whole play-by-play instead of the main point.

While it's great that you hear God a lot, the downside can be that *you hear God a lot*! And while that might be fruitful for your relationship with God, offering others every play-by-play word can be too much.

TEMPTATION: You may be tempted to share all the words, rather than just the most important ones.

PRACTICE: Ask God to help you pinpoint the most important elements to share.

JOURNAL: Take some time to journal with God to confess this temptation in your life and solidify your commitment to share only what's necessary. Then listen and record what you hear or even what God tells you to do.

Hearers tend to be independent and overvalue what they've heard over what others are sensing.

If you've heard from God, you may expect everyone else to just get on board and get with the program.

TEMPTATION: You may be tempted toward an unhealthy independence that isolates others.

PRACTICE: Find ways to involve others by welcoming them to share what and how God is speaking to them.

JOURNAL: Take some time to journal with God to confess this temptation in your life and solidify your commitment to include others in the process. Then listen and record what you hear.

HOW TO MATURE AS A HEARER

Now that you're familiar with the strengths and weaknesses of your Prophetic Personality, God wants to equip you to mature as a Hearer.

Document your hearing with journals, voice memos, and even sticky notes.

Your responsibility as a Hearer is to be a good steward of what you hear, and capturing God's words—in whatever way makes the most sense for you—is the best way to do that.

STRATEGY: Find convenient, practical ways to "capture" what God has given you. Check the method that most jibes with who you are:

- ☐ Journal, notebook, blank book, spiral notebook
- ☐ Voice memos
- ☐ The Notes app on my phone
- ☐ Sticky notes I post where I can see them
- ☐ Dry-erase marker on my bathroom mirror
- ☐ Something else: _____

STOP AND PRACTICE RIGHT NOW: What needs to happen for you to begin implementing this method of documenting how you best hear God today? If you need to pick up one of the items in the list from the store, either go out and purchase it or add it as a to-do on your calendar *now*.

Build your faith by regularly revisiting what you've documented.

When you reread what you've heard from God, it builds your faith. I'm even convinced that God will honor your faithful stewardship by entrusting you with more.

STRATEGY: Record what God has spoken on index cards and place them where you can see them often.

STOP AND PRACTICE RIGHT NOW: You might not have index cards on hand. So whether you write it inside the cover of your Bible

or make yourself a screen saver for your phone or scrawl it in lipstick on your bathroom mirror, record and display one thing you know that God has spoken to you.

Invite the Lord to speak to you throughout the day.

When you intentionally open yourself to receive God's words, God sees your willing heart.

STRATEGY: Throughout your day say, "Speak, Lord, I'm listening."

STOP AND PRACTICE RIGHT NOW: Stop and spend some time with God, speaking aloud "Speak, Lord, I'm listening."

Ask God for clarity on what to share with whom and when.

Use wisdom to discern the difference between when you should be hearing and when you should be sharing.

STRATEGY: Ask God to show you the right timing for sharing what He has said. Ask Him to remove any obstacles, such as pride, that could hinder you.

STOP AND PRACTICE RIGHT NOW: Ask God for help. (It's really that simple!)

Practice building trust with those around you.

Having someone else pray with me and talk through what I've heard from God has been a great gift to me, and I encourage you to include others in your hearing process. Then wait on God for the right timing to share what you've heard.

STRATEGY: When God has given you a word, share with someone what you've heard from God, then wait. See if they want to hear more. Be patient and wait for God's timing.

STOP AND PRACTICE RIGHT NOW: Identify the person you want to approach to help you discern the most recent word you've heard

from God. Then, to jog your memory, make a note in your phone of what you plan to share with them.

———

Beloved Hearer, the body of Christ needs you. Continue to grow and mature in the unique way you've been designed to receive from God. Rest in God's intimate care for you and be faithful to share what you've received with others.

DEVELOP THE SEER

MAYBE YOU WERE UNAWARE OF WHAT A PARTICULAR fashion designer's logo looked like, but once you discovered it, you started to see it *everywhere*. Have you ever experienced that?

What surprised me in my research on the Prophetic Personalities is that most Seers didn't know at first that they were Seers. But once they saw something, they realized they'd been seeing their whole life. They just hadn't known what it was!

Are you one of those Seers who's just learning you're a Seer? Maybe you're becoming aware that God has been speaking to you your whole life. I'm hoping that the glimpses you're getting in this book are opening your eyes to see all that God has for you. And I have prayed that you'd start seeing God everywhere.

Does any of this sound like you?

- He created you to use your imagination to find creative ways to reach your world.

- He created you to dream so you could envision another way of living, sparking hope.
- He created you to dream up stories of redemption, epic moments that inspire others to join you on the journey of life.

A REFRESHER

If you've discovered you're a Seer, congratulations! Now that you know how God is likely speaking to you, you can devote yourself to becoming a good listener.

Let's review what it means to be someone who hears from God as a Seer:

- God speaks to you in dreams, daydreams, pictures, images, and visions.
- You see things as complete or finished from the very beginning.
- You are filled with great faith that what you've seen will come to pass.
- You can see beyond what most people see.

Once again, what is true of every Prophetic Personality—including you as a Seer—is that your strengths are an outgrowth of your relationship with God. They don't *create* your relationship, but they are supernatural benefits of a healthy and intimate relationship with your Creator. So as you continue to nurture your personal relationship with God, you will grow in your ability to see.

I want to equip you to be faithful to use your gifts as a Seer, and in order to be a good steward of the unique way you're made, you need to be aware of both your strengths and your weaknesses.

STRENGTHS OF A SEER

As I share with you a bit of what we know about Seers, I welcome you to reflect on where you've noticed this type of experience in your own journey—even if you didn't receive it as God's voice at the time!

Seers see more than most people see.

Because God gives you full, vivid images, you often see what God does before others can see it. Whether God gives you a glimpse of what's in your future or someone else's, you have faith for the invisible to become visible.

As you consider your experience, when was a time that you saw a picture or caught a glimpse of what God showed you before others could see it?

Seers have a vision that empowers them to take risks.

Though you know there's a cost to sharing what you've seen, you're willing to take risks for the sake of the vision. Willing to step into uncertainty, you're bold and courageous like Joshua!

As you consider your experience, when did you take a risk because of what God had shown you?

God entrusts Seers with big dreams.

Whether God shows you the big dream in one glimpse or it's given to you in little pieces, He designed you with imagination and the ability to see what's possible.

As you consider your experience, when have you received a picture from God of what was to come?

Seers' visions spark faith in the impossible.

When God shows you an image, you have faith for it to happen (even if there's a little doubt mixed in there!). You may not have all the answers, but you see enough to believe that with God all things are possible (Matt. 19:26)!

As you consider your experience, when have you received a word that seemed bigger than what was humanly possible?

WEAKNESSES OF A SEER

Just as it's important to notice the unique strengths that Seers possess, you'll also benefit if you can be aware of the weaknesses and temptations that are unique to Seers.

Seers have a hard time when others don't see what they see.

Because not everyone has your ability to see, you might have a hard time being patient with those who are slow to see what you see. You might need to lovingly explain the vision more than once.

TEMPTATION: You may be tempted to lose your patience with those who can't yet see what you've seen.

PRACTICE: With patience, overlook others' human limitations. Confident that it's God's vision and not yours, invite them to help bring the vision to pass.

JOURNAL: Take some time to journal with God in a personal notebook: confess this temptation in your life and solidify your commitment to practice patience. Then listen and record what you hear.

Seers can focus so hard on the future that they grow weary of the present.

Because dreaming with God is such a big adventure, you may start with a ton of enthusiasm! But you can grow tired of waiting for the vision to come to pass.

TEMPTATION: You may be tempted to doubt that you're even heading in the right direction.

PRACTICE: Ask God to help you enjoy the journey. Specifically, ask God, "What step can I take today to see more clearly?"

JOURNAL: Take some time to journal with God to confess this temptation in your life and solidify your commitment to enjoy the journey. Then listen and record what you hear through your spiritual eyes.

Seers can become disillusioned.

As a Seer you're at risk of becoming discouraged, even dipping into a dark season. Maybe you've tried to carry your vision alone. Or maybe you expected to fulfill every one of your dreams in your lifetime.

TEMPTATION: You may be tempted to lose heart because what you've seen isn't materializing immediately.

PRACTICE: Cling to the words of the apostle Paul: "Let us not grow weary or become discouraged in doing good," he wrote, "for at the proper time we will reap, if we do not give in" (Gal. 6:9 AMP).

JOURNAL: Take some time to journal with God to confess this temptation in your life and solidify your commitment to refuse to become discouraged. Then listen and record what you see.

Seers can struggle with day-to-day responsibilities.

Finding the will to do the daily work is an apparent disconnect for the Seer. You have big dreams, but you may struggle to keep up with your day-to-day responsibilities.

TEMPTATION: You may be tempted to act only in the future, neglecting the present.

PRACTICE: If you're a Seer, then your eyes may be focused someplace other than the daily stuff you need to get done. There are

two ways to handle your business in the present: you can invite others in who can help you get it done, or—and I do recommend this discipline—you can buckle down and *just do it.*

JOURNAL: Take some time to journal with God to confess this temptation in your life and solidify your commitment to handle your daily responsibilities. Then listen and record what you hear.

HOW TO MATURE AS A SEER

Now that you're familiar with the strengths and weaknesses of your Prophetic Personality, God wants to equip you to mature as a Seer.

Write down what you see.

Just like the Hearer, your responsibility as a Seer is to be a good steward of what God gives you, and capturing God's vision—in whatever way makes the most sense for you—is the best way to do that.

Check the method that most jibes with who you are:

- ☐ Journal, notebook, blank book, spiral notebook
- ☐ Voice memos
- ☐ The Notes app on my phone
- ☐ Sticky notes I post where I can see them
- ☐ Dry-erase marker on my bathroom mirror
- ☐ Something else: _____

STRATEGY: Seer, capturing what God has shown you is especially important for you and your unique wiring because there can be quite a distance between your vision and the finish line. Capturing your visions will help you hold on to what God has shown you!

A technique that might also serve you well is to create a vision board, a poster-size collection of images, materials, scriptures, and other reminders of the big dream God has given you.

STOP AND PRACTICE RIGHT NOW: What needs to happen for you to begin implementing either the regular chronicling or big vision-board technique today? If you need to pick something up from the store, put it on your to-do list *now.*

Write the vision but also the practical steps to get there.

In Habakkuk, God said, "Write down the revelation and make it plain on tablets so that a herald may run with it" (2:2). As the person who sees the big picture, you have the responsibility of leading others to the vision. Are you all in step? Rather than repeating the same thing over and over, make it plain for those who will receive it.

STRATEGY: As a Seer, it's important to get precise about your core values and priorities. As best you can, answer the key questions about your vision—who, what, when, where, why, and how—and keep up with your journaling and writing as God reveals the answers to you.

STOP AND PRACTICE RIGHT NOW: Begin the process of clarifying your core values and priorities.

Ask someone to help hold you accountable to the vision.

If you have a hard time staying on track all by yourself, you're not alone. Find an accountability buddy, and your chances of reaching your goals go way up! It's just smart to seek counsel from others.

The writer of Proverbs exhorted, "Let the wise listen and add to their learning, and let the discerning get guidance" (1:5).

STRATEGY: Find the people who can be in a squad that can help you reach your goals. And here are some great questions to consider with them:

- How will I measure my progress?
- What does obeying God look like?
- How will I know that I'm living in support of the vision?
- What needs to change to make this happen?
- What do I need to tend to in my heart, mind, habits, and daily life?
- What do I need to change to get where I'm going?

STOP AND PRACTICE RIGHT NOW: Make a list of people who might be the right crew for you. Welcome the Holy Spirit to help you.

PRO TIP: Having at least one organizational visionary on your dream team is key. Ideally this person has strong administrative gifts and keen attention to detail. Their strengths in the hustle complement your weaknesses. This person can add value by helping to flesh out the details of the primary vision.

As God leads, share your vision with people who are present in it.

God often gives us images and insights for others.

STRATEGY: Write down what you've seen and meditate on why a particular person showed up in your dream. Ask God what He wants you to understand about it. With God's release and the person's permission, courageously share the dream.

STOP AND PRACTICE RIGHT NOW: Capture what you've seen by

CREATED TO HEAR GOD JOURNAL

writing it here, and ask God to let you know when you're released to share it with others.

Be patient, resist disillusionment, and trust God's timeline.

Give yourself grace and patience for the journey. Find the balance between holding on to your vision and remaining flexible enough to let it unfold in God's perfect time.

STRATEGY: Cling to this prayer of the psalmist: "I will see the goodness of the LORD in the land of the living. Wait for the LORD; be strong and take heart and wait for the LORD" (27:13–14).

STOP AND PRACTICE RIGHT NOW: Write out the passage from Psalm 27, and reflect on what God wants to speak to you in those words.

Beloved Seer, the body of Christ needs you. Keep learning to honor what God says to you through your seeing. Receive what God has for you and continue to be faithful to share with others what you've seen.

108

DEVELOP THE FEELER

WHEN JOSHUA WALKED INTO A WORKSHOP AT A SONG- writing conference, he immediately felt something was off. As he asked God what it was, God showed him that it was a spirit of fear. But Joshua had another question for God: Is it mine? Or is it someone else's?

One of the best questions for you as a Feeler is "Did I walk in with this, or did someone hand it to me when I walked in the door?" If the answer is "I picked this up," then you can be confident it's not yours. You can tell your enemy, "That's not mine!" Then, if God asks you to come to the aid of someone who needs help you can provide, you can do that.

When God showed Joshua that it was actually the instructor who was the host for that spirit of fear, Joshua knew exactly how to pray for him.

Routinely cleansing your heart will protect a healthy perspective so you can hear God for your benefit and others'. So if you're going to develop as a healthy Feeler, you'll want safeguards in place.

A REFRESHER

If you've discovered you're a Feeler, congratulations! Now that you know how God is likely speaking to you, you can devote yourself to becoming a good listener.

Let's review what it means to be someone who hears from God as a Feeler:

- God speaks to you through emotions and sensations.
- You have an unusual sensitivity to your surroundings.
- Your emotions give insight into what's going on in the heart of God.
- You can be a powerful intercessor.

As I'll continue to repeat, what is true of every Prophetic Personality—including you as a Feeler—is that your strengths are an outgrowth of your relationship with God. They don't *create* your relationship, but they are supernatural benefits of a healthy and intimate relationship with your Creator. So as you continue to nurture your personal relationship with God, you will grow in your ability to feel.

I want to equip you to be faithful to use your gifts as a Feeler, and in order to be a good steward of the unique way you're made, you need to be aware of both your strengths and your weaknesses.

STRENGTHS OF A FEELER

As I share with you a bit of what we know about Feelers, I welcome you to reflect on where you've noticed this type of experience in your own journey—even if you didn't receive it as God's voice at the time!

Feelers have a unique ability to experience God's emotions and catch spiritual nuances others miss.

You catch the emotions of God and bring them into the presence of others to be witnessed and experienced.

As you consider your experience, when was a time that you caught a spiritual nuance that others may have missed because you felt it or "sensed" it?

Feelers lead with compassion and empathy.

As a Feeler you experience empathy and compassion straight from the heart of God. Doing so brings you closer to others and reflects the compassionate heart of God.

As you consider your experience, when were the times when you felt a deep—even overwhelming—sense of compassion or empathy for others?

Feelers are attuned to others' emotions.

I understand that while it can sound odd or even distressing to experience the emotions of others, it's a way that God grants insight into what is happening under the surface of their lives.

As you consider your experience, when have you experienced a powerful emotion that likely belonged to someone else? What convinced you of this?

Feelers experience God's emotions for others, allowing others to experience God's feelings for them.

Because you can tap into God's emotions for others, you can share with them God's great care for them. You can be God's container of affection, compassion, and love for those who might not be able to access God's presence in that special way without you.

As you consider your experience, when have you felt God's care for another and had the opportunity to share it with them?

Feelers discern what's under the surface of an environment.

When Feelers enter a room, they can pick up on the emotional undercurrents in that space. And they may be especially sensitive to negative feelings.

As you consider your experience, when have you noticed the unseen undercurrents in a space?

WEAKNESSES OF A FEELER

Just as it's important to notice the unique strengths that Feelers possess, you'll also benefit if you can be aware of the weaknesses and temptations that are unique to Feelers.

Feelers have difficulty functioning when things don't feel right.

As a Feeler your emotions can make you feel vulnerable. And even when you try to stuff your feelings, they can leak out—taking down anyone in the vicinity, including you! Unhealthy Feelers can have a tough time functioning when strong emotions overtake their hearts and minds, being manipulative without totally understanding what they're doing or why.

TEMPTATION: You may be tempted to allow your feelings to bully you and others.

PRACTICE: Learn how to identify which emotions belong to you, which belong to God, and which belong to others, as well as which are directing you to intercession and which God is employing to give you discernment.

JOURNAL: Take some time to journal with God in a personal notebook: confess this temptation in your life and solidify your commitment to identify your emotions and how to best steward them. Then listen and record what you hear.

Unhealthy Feelers bring confusion, not clarity.

When you're first learning to acknowledge yourself as a Feeler, you may get it wrong.

TEMPTATION: You may be tempted to despair if you're not given the green light to express your emotions in a particular environment.

PRACTICE: Allow others in your community to help you discern what you're hearing and how to express it.

JOURNAL: Take some time to journal with God to confess this temptation in your life and ask Him to help you learn how to bring clarity instead of confusion. Then listen and record what you hear.

Feelers can overvalue their feelings and make others uncomfortable.

When you're really getting into that special connection with God, it's easy to get so wrapped up in it that you might unknowingly make others feel uncomfortable, maybe even left out. Just be mindful of that, okay?

TEMPTATION: You may be tempted to get caught up in your intimate experience with God in a way that makes others uncomfortable—and potentially excludes them.

PRACTICE: Ask God for discernment, awareness, humility, and meekness.

JOURNAL: Take some time to journal with God to confess this temptation in your life and commit yourself to choosing the humble way. Then listen and record what you hear.

Some Feelers undervalue their feelings.

If you grew up believing that you should distrust your emotions as chaotic, negative, or manipulative, your ability to engage God in your emotions may be limited.

TEMPTATION: If you were taught that feelings are unsafe—or even sinful!—you may be tempted to ignore your feelings altogether.

PRACTICE: Pause to spend time noticing where you land between the extremes of overvaluing and undervaluing your feelings.

JOURNAL: Take some time to journal with God to confess this temptation in your life and ask God to teach you how to make your emotions available to Him. Then listen and record what you hear.

HOW TO MATURE AS A FEELER

Now that you're familiar with the strengths and weaknesses of your Prophetic Personality, God wants to equip you to mature as a Feeler.

Anchor yourself in truth instead of only what you feel.

What will keep you safe is anchoring yourself in "who God is," not just "who you feel God is." Make sense? Your emotions can be

an ever-changing landscape, but you can find stability and security when you anchor yourself, root yourself, in the Word of God.

STRATEGY: When you spend time learning, studying, and memorizing what God has said, it will become a part of you—so much so that when you feel pulled in one direction by your feelings and another direction by someone else's words or actions, you'll have an immediate understanding as to which course is right for you.

STOP AND PRACTICE RIGHT NOW: Grab a study Bible that has an index or a concordance—or you can just use good ole Google— and find five scriptures that speak about God's Word, God's voice, or God's truth. Write them here.

Instead of dismissing your feelings, ask God about them.

When your feelings begin to bully you, it can be tempting to dismiss them. But God can be your guide through what can feel like a wilderness of emotion.

STRATEGY: Ask God to grant you the wisdom that silences confusion.

STOP AND PRACTICE RIGHT NOW: Get very specific with God, asking "Why do I feel overwhelmed?" or "Why do I feel so emotional?" Then lean in and listen! Record here what you hear.

Keep your heart clean.

Your heart is the filter for everything that comes at you, and you need to keep it clean. (Otherwise it's like having dirty glasses!)

STRATEGY: Ask God to show you any smudge, dirt, stain, or impurity that could be clouding your heart.

STOP AND PRACTICE RIGHT NOW: Pray the prayer that David prayed: "Search me, God, and know my heart; test me and know my anxious thoughts. See if there is any offensive way in me, and lead me in the way everlasting" (Ps. 139:23–24). Spend time in silence listening for God's voice, and record here what you notice.

Embrace the power of prayer and pray until joy comes.

Prayer is a powerful partnership between you and God.

STRATEGY: As a Feeler, you need to pray and ask God to help you discern what you're experiencing and where it's coming from. Ask God to show you if it's yours or if it's something in the area— and how you are to respond.

STOP AND PRACTICE RIGHT NOW: If you're carrying the burden of someone else's feelings right now, stop and begin to practice intercession (talking to God on someone else's behalf). Invite the Holy Spirit to pray in you and through you.

Have your feelings but don't allow them to "have you."

If you're new to allowing or receiving feelings and haven't yet matured in your listening, you might feel like your feelings are in control.

STRATEGY: When you feel things intensely, remain submitted to your community and to God.

STOP AND PRACTICE RIGHT NOW: Notice an area in which your feelings "have you." After acknowledging it, ask God what He wants to do. Listen and record it here.

Learn which feelings are yours and which are not.

As you mature in your Prophetic Personality, you'll learn to quickly identify which feelings are yours and which are not. Here's a great rubric I learned from my co-teacher, Jason.

A feeling might be *from you* if

- it reflects something you have been dealing with or been previously aware of,
- the Holy Spirit is convicting you of a need to repent, or
- you examine your heart before God and see you are hiding something from Him.

A feeling might be *from someone else* if

- it arises out of the blue and catches you off guard,
- it generates confusion, or
- other people are sensing something similar.

STRATEGY: Pause to identify whether a big feeling is yours or not.

STOP AND PRACTICE RIGHT NOW: Recall a situation in which you were unsure whether a feeling was yours or not and use Jason's rubric to help you discern. Jot down here what you learn.

▬▬▬▬

Beloved Feeler, the body of Christ needs you. Keep learning to honor what God says to you through your emotions. Notice what is yours and what is not. And use your unique gifts to care for others.

DEVELOP THE KNOWER

WHEN I FINALLY ACCEPTED MY UNIQUE STYLE OF hearing—as a Knower—I stopped beating myself up for not experiencing God the way others did. As you might imagine, it was wonderful! And the result was that I finally felt spiritual confidence.

This is my heart for you as well. I am not playing when I say that discovering your Prophetic Personality can change your whole spiritual life overnight.

A REFRESHER

If you've discovered you're a Knower, congratulations! Now that you know how God is likely speaking to you, you can devote yourself to becoming a good listener.

Let's review what it means to be someone who hears from God as a Knower:

- God shows up in your world as intuition, or an inner confidence in what is true.
- God speaks to you in your "knower."
- You have supernatural intuition and insights.
- You just *know* in your spiritual gut that God is speaking to you, and you respond to Him.

As I have said all along, remember that your strengths are an outgrowth of your relationship with God. They don't create your relationship; they are supernatural benefits of a healthy and intimate bond with your Creator. (So if you want to hear, make that relationship a priority!)

I want to equip you to be faithful to use your gifts as a Knower, and in order to be a good steward of the unique way you're made, you need to be aware of both your strengths and your weaknesses.

STRENGTHS OF A KNOWER

As I share with you a bit of what we know about Knowers, I hope that you'll reflect on where you've noticed this type of experience in your own journey—even if you didn't receive it as God's voice at the time!

Knowers have a unique ability to push through barriers and overcome anything that stands in their way.

Knower, you do hard things really well, pushing through obstacles and overcoming them in extraordinary ways.

As you consider your experience, when was a time that you pushed through a barrier that might have stopped someone else?

Knowers possess a strong sense of direction.

If you're a Knower, your faith links with your spiritual gut. You just *know it* in your deep places.

As you consider your experience, when were the times when you just knew in your gut something that wasn't plain to others?

Knowers are resistant to being swept away by emotion or hype.

If you're a Knower, you're going to discern something without employing the more tangible senses of hearing, seeing, or feeling. You just *know* that you know.

As you consider your experience, when have you known something that others—who discern with hearing, seeing, or feeling—didn't know?

Knowers possess an unusual degree of hope.

As a Knower, you believe God is going to come through. You have an expectation that something good will happen in the future.

As you reflect, when have you experienced an unusual degree of hope, meaning "more than others around you," because you trusted that God would come through?

WEAKNESSES OF A KNOWER

Just as it's important to notice the unique strengths that Knowers possess, you'll also benefit if you can be aware of the weaknesses and temptations that are unique to Knowers.

When Knowers feel left out of spiritual experiences, they are vulnerable to disengaging from their spiritual life.

As a Knower, you may feel miffed as those around you talk about hearing, seeing, and feeling God speaking directly to them. (I mean, really . . . what *is* that?!)

TEMPTATION: You may be tempted to believe that you're the most unspiritual person in the room.

PRACTICE: Keep clinging to God and accepting that the way God speaks to you is unique! (Promise me you won't try to fake anything.) Trust that God is communicating with you even when you don't feel it.

JOURNAL: Take some time to journal with God in a personal notebook: confess this temptation in your life, and go one step further by journaling your appreciation for those with different ways of hearing! Then listen and record what you hear.

Knowers have a hard time valuing other modes of hearing God.

While you might envy the other Prophetic Personalities, you might also be quick to dismiss them. (Sound nutty? You know I'm right.)

TEMPTATION: Driven by pride, you may be tempted to judge others' ways of hearing God.

PRACTICE: Confess your pride to God and ask Him to help you see the value of each mode of hearing.

JOURNAL: Take some time to journal with God to confess this temptation in your life and ask Him to give you vision to see how others' unique wiring can benefit the world! Then listen and record what you hear.

Knowers tend to overvalue their knowing and leave others behind.

When you get clear about what you know, you may push the gas pedal and leave others in the dust.

TEMPTATION: You may be tempted to believe that you're the only one in your world that God is speaking to.

PRACTICE: Asking God to help you adjust your prideful thinking, nurture a connection with a healthy person who honors your knowing *and* holds you accountable to authority and wisdom.

JOURNAL: Take some time to journal with God to confess this temptation in your life and ask Him what your next step should be to get or stay connected to community. Then listen and record what you hear.

Knowers can miss God's direction because they presume to know His destination.

If you think you see the final outgrowth of what God is up to, you're at risk of missing out on what God is doing *right now.*

TEMPTATION: If you're certain you know God's plan, you may be tempted to miss out on God's guidance.

PRACTICE: Find practical ways to keep your eyes on God moment by moment.

JOURNAL: Take some time to journal with God to confess this temptation in your life and ask Him to stay near to you. Then listen and record what you hear.

HOW TO MATURE AS A KNOWER

Now that you're familiar with the strengths and weaknesses of your Prophetic Personality, God wants to equip you to mature as a Knower.

Develop your supernatural wisdom by leaning into the mind of Christ.

In his letter to the church in Philippi, the apostle Paul exhorted, "In your relationships with one another, have the same mindset as Christ Jesus" (Phil. 2:5). As a Knower, you will be well-served—and will be able to serve *others* well—if you develop the mind of Christ.

STRATEGY: The strategy to develop the mind of Christ is as fundamental as getting good nutrition, hydration, exercise, and rest. It's also fourfold:

1. Study Scripture.
2. Cultivate a life of prayer.
3. Stay connected to a faith community.
4. Adopt other spiritual disciplines that deepen your connection to God.

STOP AND PRACTICE RIGHT NOW: Which of these four spiritual health pillars is weakest in your life? Pause to write down your commitment to grow in this area. (Hint: being specific about what you need to practice is going to be more useful than being vague.)

Allow God to build a history of knowing with you.

Your confidence as a Knower is critically connected to your history of listening to God.

STRATEGY: In every situation, obey God's leading and trust Him to honor your intent and correct you if you're wrong.

STOP AND PRACTICE RIGHT NOW: Take a moment to review your history—long or short—of hearing God and obeying Him. Then give God thanks for all of it!

Nurture humility so God can lead you.

As a Knower, you can cultivate humility by acknowledging that you don't have all the answers.

STRATEGY: Live fully submitted to God and trust His leading in every moment.

STOP AND PRACTICE RIGHT NOW: Pause and write out this prayer: "God, I'm fully submitted to You. Do whatever You want to do in my life." Then speak it aloud. What is God saying to you?

Don't believe the lie that you're not spiritual enough.

Reject this lie—it's from the Enemy!—once and for all.

STRATEGY: Adopt this mantra: "Just because I hear God differently doesn't make me wrong. It makes me different."

STOP AND PRACTICE RIGHT NOW: Stand up, walk to the closest mirror, and speak this aloud: "I'm a Knower. I will value the fact that with the gift of knowing comes the gift of wisdom. I will build my confidence on my history with God. He has made me a Knower with supernatural intuition, and I can grow and steward my knowing!"

Embrace discomfort.

In order to mature as a Knower, you will need to push beyond your comfort zone and actively seek discomfort. (Sorry, not sorry.)

STRATEGY: Reject the temptation to separate from others and withdraw.

STOP AND PRACTICE RIGHT NOW: Who's the first person you think of with whom you disagree on spiritual matters? Call or text them to set up a time to share your different perspectives with one another. Will it be uncomfortable? Likely. Will you benefit? Absolutely. Be sure to pray before and after the conversation and depart in grace and love.

Learn to articulate what you know with phrases that others are less likely to interpret as self-proclaimed.

Point to God as the source of your knowing rather than yourself. (Trust me, shifting your language from "I know" to "God showed," or something similar, is going to help others to *hear* you.)

STRATEGY: Integrate language that is gentler, pointing to God as the source of your knowing.

STOP AND PRACTICE RIGHT NOW: Finish the following sentences with your own words:

- God said _____.
- God showed me _____.

- God moved my heart _____.
- (Or what might feel most comfortable for a Knower) God impressed on me _____.

━━━━━━

Beloved Knower, the body of Christ needs you. Keep listening to what God is saying to your gut! We need you to trust that revelation and share it with us.

HERE'S WHERE WE ARE, AND HERE'S WHERE WE'RE GOING

SO, WHAT DID YOU THINK AS YOU EXPLORED YOUR Prophetic Personality type? Did it resonate with you?

You have the rest of your life to continue to learn and grow in the way you hear God.

And to be clear: you need to keep learning and growing!

In the closing chapter, I want to offer you some fuel for the journey so that you can continue to grow closer to God by hearing His voice.

ESSENTIALS FOR THE JOURNEY AHEAD

I AM CONVINCED THAT BY HONORING OUR UNIQUE Prophetic Personalities, our lives are radically transformed. We're able to hear God as He pours out His love on us. We receive guidance and direction for ourselves and others. We're more confident because we trust in God's leading, and we're no longer pushed and pulled by the opinions of others.

As we purpose to live well, there are some foundational truths that will keep us anchored to God.

WE ALL NEED RELATIONSHIP WITH GOD

When I was learning how to use my knowing, I noticed something that was kind of surprising: Even though I was hearing God's voice

regularly, I wasn't growing closer to Him. I actually felt further from Him than ever! As this unsettling reality dawned on me, God told me what was going on: I was having a transactional relationship, not an intimate one. As soon as God dropped that on me, the light bulb came on and I understood.

Maybe you've had a season when your relationship with God felt transactional. Maybe you were only in God's Word so that you could hear a message to deliver to the congregation on Sunday morning. Or maybe you were listening according to your Prophetic Personality, but you were only engaged as a mouthpiece for God to speak to someone else.

Recall a season in which you may have appeared to be close to God but were neglecting the kind of personal relationship that leads to intimacy with Him. Identify that season and dialogue with God about it, then record what you hear.

In chapter 2 we looked at God's character in the book of Exodus as He delivered His people from slavery. God assured Moses:

> "I have indeed seen the misery of my people in Egypt. I have heard them crying out because of their slave drivers, and I am concerned about their suffering. So I have come down to rescue them from the hand of the Egyptians." (3:7–8)

In God's tender care for His people, we see His character as the One who sees, who hears, who feels, and who knows. This is who God is!

I want you to have the opportunity to encounter the God who hears you, who sees you, who feels for you, and who knows you. So pause to spend some time with these passages; they reveal how God, the one who designed our Prophetic Personalities, actually embodies those very qualities. Look up each verse in your Bible or on your phone and jot down what stands out to you:

God hears.

- John 9:31
- 1 John 5:14

God sees.

- Genesis 16:13
- Proverbs 15:3

God feels.

- Jeremiah 31:3
- Psalm 103:13

God knows.

- Psalm 147:5
- 1 John 3:20

What, if anything, was new or surprised you from what you read?

WE ALL NEED TIME TO GROW CLOSER TO GOD

There was a season in my life as a single woman when I could spend endless leisurely, luxurious hours studying God's Word. Years later in a new season, I was married, a mother of four, and an ordained minister. I don't have to tell you that nothing about that season was leisurely or luxurious. And while I'd carve out time to sit with God, that time got shorter and shorter.

You might have other responsibilities tugging at your time: an extra job, studying for a degree, entrepreneurial ventures, care for a loved one, or any number of other things that require your time.

As you think back over your life, when was—or *is*—the season when you were most easily able to spend uninterrupted intimate time with God? Describe your experience.

As you think back over your life, when was—or *is*—that season when it was most *difficult* to spend uninterrupted intimate time with God? Describe your experience.

I want to take away the shame we can feel about the natural shifts in our spiritual lives by naming that there are real pressures in various seasons. But I also want to say that we can exercise some creativity in the ways that we make space for an intimate relationship with God.

Could any of these strategies that make room for intimacy with God have your name on them?

- ☐ Bible-teaching podcast
- ☐ Phone app that narrates the Bible
- ☐ Audiobook that feeds your soul
- ☐ Turning off the music during exercise time to listen to God
- ☐ Maximizing your commute to work by giving it to God
- ☐ Something else: _____

Ask God how you can find the time you need to spend with Him. Then *listen*. Record what you discover.

WE CAN ALL GROW

Just as babies begin by drinking nutrient-rich milk and eventually mature to enjoying burgers and salads and fruit and milkshakes, each of us was designed to keep growing in the Lord. No matter how much we mature, we never reach a plateau where we no longer need to be fed! The Bible is our pantry. Whatever fuel we need for the journey can be found in the pantry of God's good provision.

If you're in the regular habit of spending time in God's Word, what is He showing you right now? (Include the Scripture reference as well.)

If you are *not* in the regular habit of spending time in God's Word, this is your lucky day. Right now you can be intentional about beginning a regular mealtime with God:

- The specific location where I will tune out all other distractions to spend time with God's Word is _____

- The specific time, today or tomorrow, when I will tune out all other distractions to spend time with God's Word is _____

- The place in God's Word where I plan to spend time is _____

WE ALL HAVE ACCESS TO GOD'S WISDOM

Some Christians have mistakenly—though *understandably*—believed that God's wisdom is carefully doled out to pastors and teachers and prophetic wizards. (JK, that's not really a thing.) I hope you're realizing that when you practice your Prophetic Personality, *you* have access to all of God's wisdom, insight, and love! You have it in Scripture, and you have it in your intimate conversations with God.

Go ahead and take a minute to sit with that. Because it really is as mind-blowing as it sounds. Yet it doesn't require any super-human gymnastics, because you were *designed* to hear God's voice.

Read the following verse and then stop and ask God for what has been promised.

Do not conform to the pattern of this world, but be transformed by the renewing of your mind. Then you will be able to test and approve what God's will is—his good, pleasing and perfect will. (Rom. 12:2)

PRAY ALOUD: God, I believe both that You will transform me and that I can know Your good will. Speak, Lord, your servant is listening. I am ready to obey.

This is what the Lord says—
 your Redeemer, the Holy One of Israel:
"I am the Lord your God,
 who teaches you what is best for you,
 who directs you in the way you should go." (Isa. 48:17)

PRAY ALOUD: God, I am confident that You are directing me in the way I should go. Speak, Lord, Your servant is listening. I am ready to obey.

WE ALL SERVE A DIVINE AUTHORITY

When anyone announces, "God told me . . . ," a lot of people feel nervous. And I get it. Sometimes people who mean well get it wrong.

When have you heard someone "speak for God" when you had evidence that what they were saying was not from God?

How do you make sense of that?

While people can get it wrong, there is still nothing that will shake my confidence that God wants to and does speak clearly to each one of us. Here's why:

The God who gives us the ability to hear, see, feel, and know Him can protect us from our own immaturity and imperfection while we learn to grow.

God has appointed authorities over us to help us test His revelations and grow in wisdom.

The most important authority for checking the legitimacy of anything we get from God is the Holy Bible.

How have you seen the body of Christ confirm that words received are from God? Be specific.

WE ALL NEED COMMUNITY

For you to mature and thrive in your Prophetic Personality, you need to be rooted in a church that can support you.

If you're not connected to a spiritual community right now, why is that?

If you are connected to a spiritual community right now, is it one where the Spirit is present and folks are hungry to grow spiritually?

If not, who can you speak with about finding a community of true support?

A FINAL NOTE FROM HAVILAH

MY DEDICATED TRAVELING COMPANION,

Just look at where we've been!

Together we've discovered that you are uniquely made to hear God. We dove into the four Prophetic Personality types, and you had the chance to uncover yours! You took a moment to explore what that looks like in your own life. And finally, you received the essential tools to keep you going on this journey with the One who loves you.

I'm beyond excited for you because I know this adventure is absolutely amazing. And it's just the beginning. Whether you've been walking with God and hearing His voice for decades or you're tuning in for the first time, God has so much goodness in store for you and those around you.

I want to encourage you to keep going. Stay curious and

connected as you're filled by the Holy Spirit. Dive into God's Word. Take time to rest in His presence. And by all means, invite others to join you on this incomparable adventure.

You got this.

Havilah

ABOUT THE AUTHOR

HAVILAH CUNNINGTON IS A SOUGHT-AFTER COMMUNICATOR, author, and top-rated podcaster, and she has been in full-time ministry for twenty-five years. In addition to being the women's pastor at Bethel Church, she and her husband, Ben, lead a nonprofit called Truth to Table. They're obsessed with reaching the world with Bible studies, messages, and lifestyle-leadership tools. Havilah is the author of *Created to Hear God, Stronger than the Struggle,* and a dozen self-published Bible studies. She resides in Redding, California, with her husband, four sons, and two dogs.

Connect with Havilah daily, see pictures of her family, and follow her speaking schedule:

Website: www.HavilahCunnington.com

Click on "Speaking" then "Speaking Request Form" to inquire about having Havilah speak at your event.

Facebook: www.Facebook.com/HavilahCunnington

Instagram: @HavilahCunnington

If you've enjoyed *Created to Hear God Journal,* equip yourself with additional resources at www.TruthtoTable.com. You can also pick up the full book, *Created to Hear God,* for an even deeper journey.

NOTES

NOTES

NOTES

NOTES

NOTES
